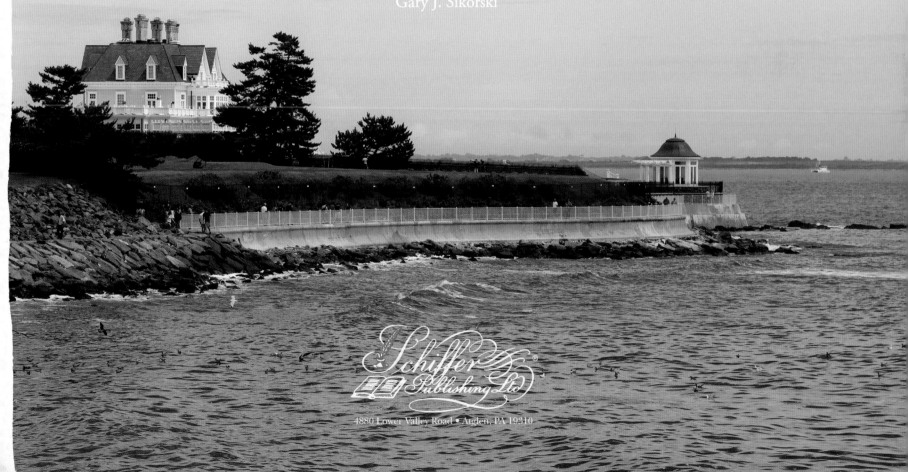

101 THINGS TO DO IN
RHODE ISLAND

Gary J. Sikorski

Schiffer Publishing Ltd

4880 Lower Valley Road • Atglen, PA 19310

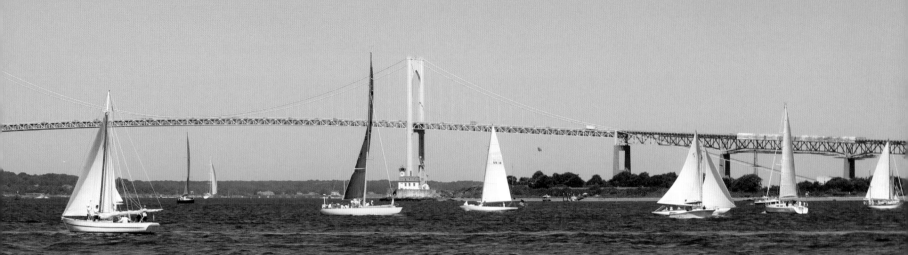

Other Schiffer books by Gary Sikorski
101 Things to Do in Martha's Vineyard,
ISBN 978-0-7643-4953-9

Library of Congress Control Number: 2016939288

"Schiffer," "Schiffer Publishing, Ltd.," and the pen
and inkwell logo are registered trademarks of Schiffer
Publishing, Ltd.

Designed by Brenda McCallum
Maps courtesy of David DosReis, GIS Manager,
City of Providence
Photos on page 55 courtesy Twin River Casino
Photo on page 71 courtesy Todd Monjar Photography
Photo on page 128 courtesy Skydive Newport.

Type set in Cinzel Decorative/Times Roman
ISBN: 978-0-7643-5138-9
Printed in China

Published by Schiffer Publishing, Ltd.
4880 Lower Valley Road | Atglen, PA 19310
Phone: (610) 593-1777; Fax: (610) 593-2002
E-mail: Info@schifferbooks.com
Web: www.schifferbooks.com

For our complete selection of fine books, please visit our
website at www.schifferbooks.com.

Schiffer Publishing's titles are available at special discounts
for bulk purchases for sales promotions or premiums.
Special editions, including personalized covers, corporate
imprints, and excerpts, can be created in large quantities
for special needs. For more information, contact the
publisher.

We are always looking for people to write books on new
and related subjects. If you have an idea for a book, please
contact us at proposals@schifferbooks.com.

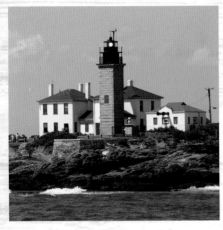
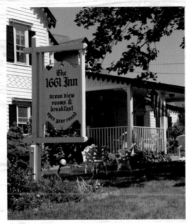

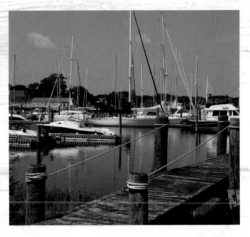

CONTENTS

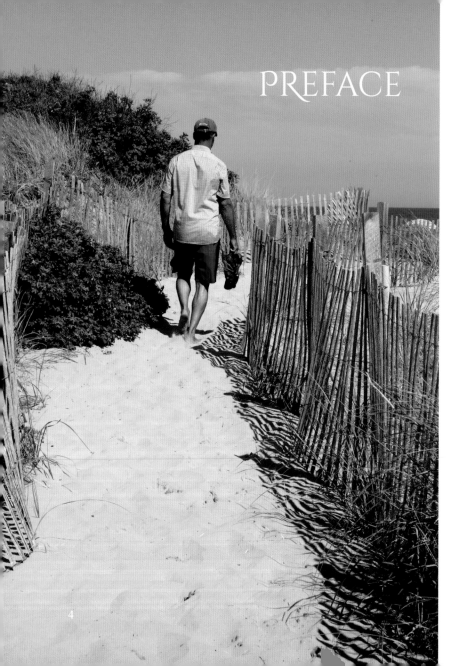

PREFACE

I am so happy to say that this book is my second in what will hopefully be many more photographic travel guides. Upon finishing the text for my first book, *101 Things to Do in Martha's Vineyard*, and reveling in the satisfaction of what I was about to accomplish, I realized that this could be the beginning of a new chapter in my life—an exciting new chapter in which I could connect my nomadic past with my future via an array of informative travel books.

Being in the restaurant industry since, well, since disco was popular, I've spent a good deal of time traveling and working mainly in prominent seasonal areas oversaturated with tourists. This usually meant I was working in the north in the summer and in the south in the winter. Not only did I go where the money was, but it allowed me to live and work in places where most people were spending their vacations. So I traveled a lot, and had the chance to spend extended periods of time getting to know a lot places very intimately. This has positioned me nicely to act as your guide and attempt to bring you these fabulous destinations through my photography. And I did just that in my first book.

So I then looked back in my past to determine the next place to which I could return and continue my "101 things to do" concept. It would need to be a popular vacation spot. A place where I knew the lay of the land. A place where I've experienced the major attractions as well as those off-the-beaten-trail places that I love telling my friends and family about. I soon realized, with the help of my friend Collette, that that place was right in front of me! The beautiful state in which I currently reside—Rhode Island! Today, it's remarkable how many people are visiting our state. Thanks to our 400 miles of coastline, the many historic sites, and the resurgence of the city of Providence, this is the place! So I went about revisiting some of my old haunts and uncovering some new ones, and in the process, compiled 101 of the best things to do to in Rhode Island. Come visit, come explore and come experience all the excitement this wonderful state has to offer. Hope to see you on the beach!

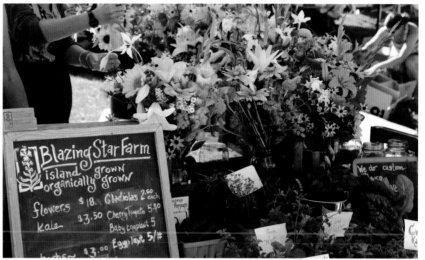

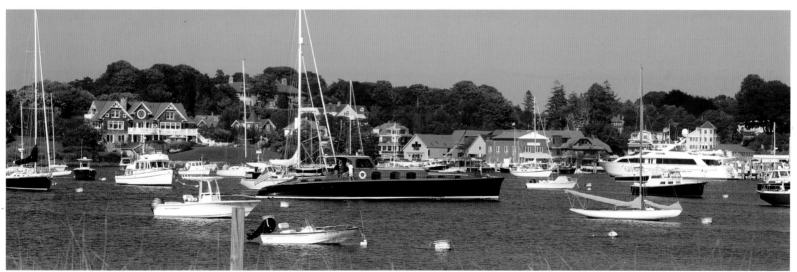

ACKNOWLEDGMENTS

It was a real treat this past year traveling around this great state compiling *101 Things to Do in Rhode Island*. I traveled with my camera by my side and was able to revisit some of my favorite places and discover some wonderful, new adventures. But I did not make this journey on my own. I traveled with the thoughtful help of many others. And to all of you, I am extremely grateful and forever thankful.

Helping me once again along the way was Collette Royer. Not only did she provide her encouragement and proofreading skills, but it was her suggestion over a coffee milk at the Modern Diner in Pawtucket that swayed me to stay put and create this book, rather than venture out to one of the other destinations I was considering. Thanks very much, Collette—you were right! And many thanks once again to my good friend Todd Monjar for his photographic advice and for the pictures he provided for WaterFire and for my biography. Todd, you're the best!

I am also very grateful to David DosReis, GIS Manager for the City of Providence. Thank you very much for your time and expertise creating the maps for this book. Much appreciated! I'd also like to smile upon Judy Courtemanche for her help reviewing and proofreading my text. Thanks a lot, cuz! I also want to send my gratitude out to Kim Ward at Twin Rivers Casino for providing the wonderful photographs of that remarkable facility and to Marc Tripari at Skydive Newport for the great shot of the folks jumping out of your plane at 10,000 feet. Wow! Thanks also go to the good folks at Island Moped for providing the means for me to get around Block Island on those long, sunny afternoons. Also, I would be remiss not to send extra chocolate cupcakes to Jennifer Madden and Aly Stallman for their contributions. Thanks very much for your help as well.

And once again, kudos and kisses to my editor, Catherine Mallette. Catherine, you have once again been so helpful and working with you has been wonderful. And a big hug to Brenda McCallum, whose wonderful design of my first two books has been magical. Peter, how did I get so lucky? Thanks to everyone at Schiffer Publishing who had a hand in *101 Things to Do in Rhode Island*. I really couldn't be happier with the way Schiffer has handled my first two books. Thank you very, very much.

Lastly, to the readers, thanks very much for picking up this book and traveling along with me. Even with 101 suggestions, there is still so much more to be discovered in this beautiful state. So get out and explore. And don't forget to try a coffee milk! Thanks very much everyone!

INTRODUCTION

Imagine sailing aboard a luxurious sunset cruise out on the Atlantic, sipping champagne in the backyard of a lavish Great Gatsby-era mansion, rummaging around centuries-old antiques shops, or ripping into a succulent two-pound lobster fresh off the boat. You are about to discover these and so many more reasons why you should visit the "smallest state with the biggest heart." Rhode Island, although just forty-eight miles from north to south and thirty-seven miles from east to west, is blessed with a parade of beautiful sandy beaches, an array of sheltered coves, a plethora of boat-filled harbors, and a host of spectacular cliffs and rocky bluffs. It all adds up to an astonishing 400 miles of coastline! The Ocean State combines this remarkable waterfront beauty with quaint towns and villages, an Ivy League university, world-class arts and theaters, and historic sites dating back 350 years in time, all within a short drive of each other. So grab your comfy shoes, and let's visit Rhode Island!

The area now known as Rhode Island was originally inhabited by Wampanoag, Narragansett, and Niantic American Indian tribes. Of these three, the proud Narragansett Indians have endured, and still gather socially around the area of Charleston. The first permanent non-native settlement was established by Roger Williams in Providence on land purchased from those Narragansett Indians. Williams had been forced to flee Massachusetts because of religious persecution, and he established a policy of religious and political freedom in his new settlement. You can still find Roger Williams's name on everything from universities to hospitals to zoos. In 1663, King Charles II of England granted Williams's settlement a royal charter authorizing the continuation of freedom of religion. Rhode Islanders rejoiced in the proclamation and, in the early 1700s, built two of the busiest ports in the New World. Providence and Newport positioned themselves to grow and expand due to these prosperous ports, and despite high profits

and the need for labor, they were part of the first colony to prohibit the importation of slaves.

As the Revolutionary War started, Rhode Islanders were among the first colonists to take action by attacking British ships. Rhode Island was also the first colony to declare independence, and that independent spirit was evident at the close of the war as Rhode Island was the last of the thirteen original colonies to ratify the US Constitution, demanding the addition of the Bill of Rights.

Industrialization was another of the hallmark achievements attributed to our state's independent, entrepreneurial spirit. In 1793, Samuel Slater built the first successful water-powered cotton mill along the Blackstone River in Pawtucket. Other manufacturers in the region followed, and the Industrial Revolution was born. Increased production meant increased jobs, and Rhode Island soon took root and expanded due to the influx of immigrants from across the sea.

Today, Rhode Island is alive with that independent spirit, which can be felt all the way from Woonsocket to Watch Hill. You will feel that spirit come to life in *101 Things to Do in Rhode Island*. We will guide you down meandering country roads and seaside highways and take you on an informative, photographic journey where you will learn about the preeminent sight-seeing destinations, the local favorites, and exciting activities you might have not known existed even if you live here. Included are interesting tips and helpful suggestions that will aid you in making the most of your visit. We'll take you on a complete voyage of the entire state, from dairy farms and quaint fishing villages to the magnificent mansions of America's Gilded Age, from fields filled with juicy blueberry bushes to world-class art galleries, and from colorful neighborhood bars and restaurants to the raging coast of the Atlantic. So whether you are looking to kick back on an elegant sailboat, enjoy freshly caught seafood along the harbor, climb to the top of a

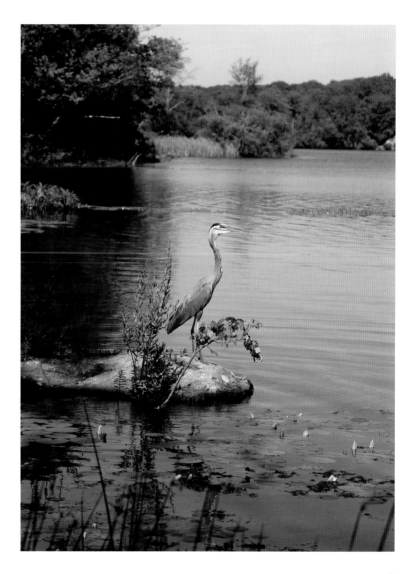

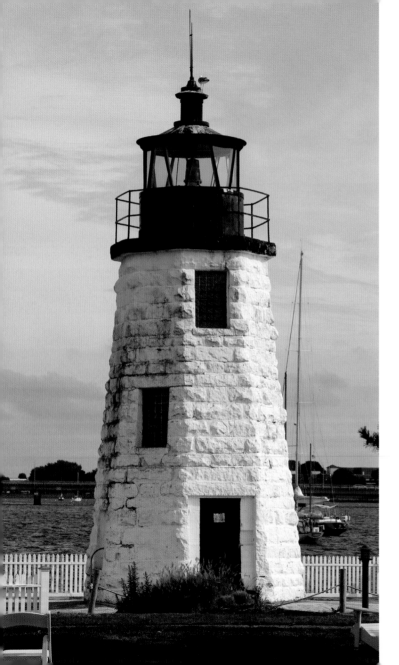

picturesque lighthouse, walk along the paths of history, or simply lie back on a secluded beach, *101 Things to Do in Rhode Island* will guide you on your adventure.

Blackstone Valley is in the northern reaches of Rhode Island. Known as the birthplace of the American Industrial Revolution, it's where you'll find Slater Mill, the first successful water-powered cotton mill in the country. Enjoy an eggroll with world-class jazz and blues performances at Chan's Fine Oriental Dining in Woonsocket; or watch them milk the cows and grab a fresh coffee milk at Wright's Dairy Farm & Bakery in Smithfield. If games of chance are on your agenda, the sparkling Twin River Casino and Entertainment Complex is open twenty-four hours a day. And the quaint little antique shops scattered throughout the charming village of Chepachet in the far northwest corner of Blackstone Valley should not be missed. The best of the bunch is Brown & Hopkins Country Store, America's oldest country store in continuous operation.

Providence is Rhode Island's capital city, and it's here that you'll find the bulk of the state's arts and theaters, along with several of the finest educational facilities in the world. Jump in a gondola and be serenaded while floating down the Providence River. Stroll along Thayer Street, lined with eclectic shops and casual eateries, and rub elbows with the Ivy League college kids from nearby Brown University. Dine at CAV Restaurant where the food is divine and the room is filled with African artifacts; or simply grab a burger at the world-famous Haven Brothers Diner—the oldest diner car on wheels in the United States. As night approaches venture over to Federal Hill, Providence's "Little Italy," for a dessert or espresso enjoyed while the sounds of live music emanate from DePasquale Square.

The central part of the state is actually divided by Narragansett Bay into two regions: Warwick/Cranston on the west and Bristol County on the east. The West Bay side is a shopaholic's paradise with lots of major retailers and popular malls. For a more intimate shopping experience, explore historic Pawtuxet Village. While there, be sure to stop into Betty's Candies for her award-winning chocolate nut clusters. Venture out to the far west and you'll run into amiable John Macomber outside the gate of his iconic blueberry farm. Stop in and pick-ur-own blueberries right off the bush. Travel around to the other side of the bay on the east and the

atmosphere changes dramatically. Bristol County combines colonial charm with stunning seaside communities and picturesque parks and gardens. Here you will find Coggeshall Farm, a 1790s working farm museum, and Blithewold Mansion with thirteen acres filled with incredible gardens, specimen trees, and historic stone structures. The quintessential New England waterfront town of Bristol, one of the most colorfully historic and patriotic towns in America, is found on this side of the bay.

Wrapped around the southernmost edge of Rhode Island is South County. Take a drive along its coast and you'll understand why Rhode Island is called the Ocean State. Discover Misquamicut Beach, with miles of sand and plenty of old-fashioned carnival rides to keep the kids happy. The serious surfers head over to Narragansett Beach, where the waves are always plentiful. The affluent coastal village of Watch Hill, with its historic Flying Horses Carousel and luxurious Ocean House resort is delightfully tucked in the far southwest corner along the Atlantic.

Last, but certainly not least, is Newport County. Most of this scenic southeast region is comprised of islands, like tiny Rose Island with her charming, welcoming lighthouse that you can rent for an evening. Or Conanicut Island, home to Jamestown and a beautiful harbor and historic lighthouse. The largest of the islands, Aquidneck Island, is where you will find the popular seaside city of Newport, famous for world-class sailing, magnificent gilded mansions, luxurious shopping, and breathtaking scenery.

101 Things to Do in Rhode Island is about to start you on your journey. It's going to be fun, but keep in mind that these are just a few of the many sights and activities that are waiting for you in the Ocean State. Each day in Rhode Island is an adventure, so go out and discover on your own. Marvel at the panoramas. Experience the vistas. Explore the trails. I've pointed you in the right direction, so put on your boat shoes, grab a frozen lemonade, and order-up a clam cake.

Turn the page, and let's go visit Rhode Island!

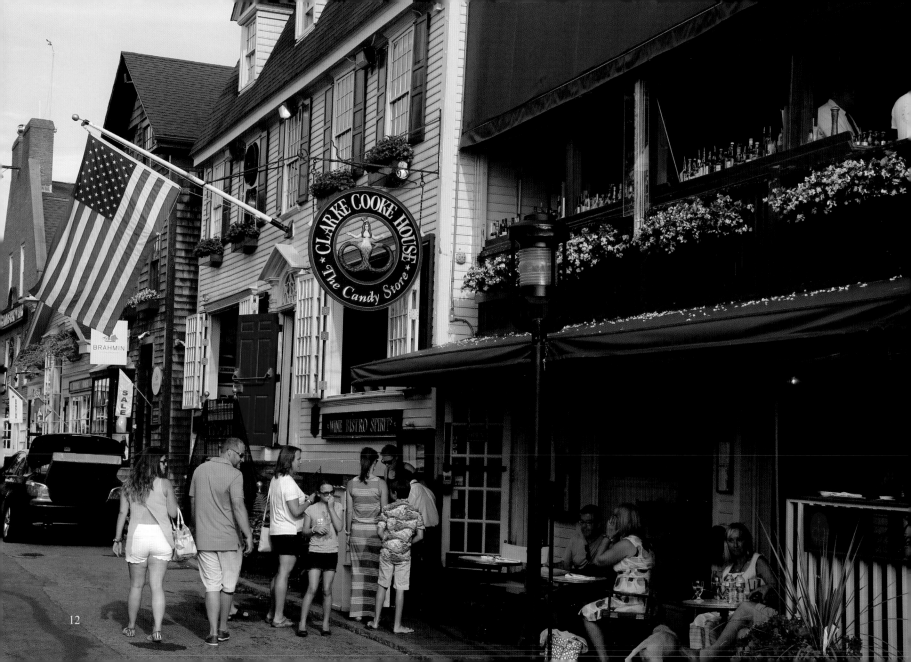

A PERFECT DAY IN
RHODE
ISLAND

Rhode Island has always been a popular travel destination, especially the sailing capital of Newport and the areas adjacent to our stunning shoreline along the Atlantic. But with the resurgence of cities like Providence, often referred to as the "Renaissance City," people are once again rediscovering other parts of this great state. Many times I'll hear the question, "I'm only here for a day or two— what should I do?" Realizing it would be very difficult, even impossible, to do all of my 101 things in one day, I've created an itinerary for those of you who are just passing through. So, for all you day-trippers, here are a few suggestions for that perfect day in beautiful Rhode Island.

9:00 a.m.	Arrive in Providence and start your day with breakfast at Julian's. The bohemian restaurant is a local favorite with creative food and al fresco dining.
10:00 a.m.	Next is a stop at Rhode Island School of Design Museum, Providence's world-class institution showcasing masterworks of fine art, sculpture, furniture, and fashion.
11:45 a.m.	Head down I-95 to the charming village of Wickford. Peek into all the neat shops and delight in the gardens. Grab a bite to eat alongside the historic harbor.
1:00 p.m.	Continue to Saunderstown. Stop in at the Gilbert Stuart Birthplace and Museum to marvel at the historic grounds and check out Mr. Stuart's masterful paintings of America's first six presidents.
2:30 p.m.	Cross over the two bridges via RI-138 and drop down into Newport. Wander along historic Bellevue Avenue and stop in at one of the magnificent mansions.
4:00 p.m.	Go for a ride along world-famous Ocean Drive, stopping at Brenton Point State Park to admire the ocean views and to pick-up a Del's Lemonade!
4:45 p.m.	Continue to Bannister's Wharf in the heart of Newport. Stroll around and do a little shopping, or jump on a sailboat cruise and spend time on the water.
7:00 p.m.	Time to head north to Bristol to discover America's most patriotic city. Stop in the Judge Roy Bean Saloon in the center of town for a cold beer and some live music.
8:30 p.m.	Arrive back in Providence in time to enjoy an extraordinary dinner and the antiques and artifacts that fill the cozy room at iconic CAV Restaurant.
10:00 p.m.	Head into Downcity and cruise around Westminster Street. Stop in at one of the many, eclectic local bars for a cocktail and a chat with a friendly bartender.
11:00 p.m.	Time to experience the Dean Hotel! Belt out a tune in the karaoke lounge, sip on a German beer in Faust or cuddle-up over a martini in the Magdalenae Room.
1:00 a.m.	Realize that you just had too much fun today and you are too tired to move on. Check in to the Dean and spend the night! Sweet Dreams!

RHODE
ISLAND

Massachusetts

Connecticut

Atlantic Ocean

26--Chan's Oriental Restaurant
88--Wright's Dairy Farm

94--Brown & Hopkin's Country Store
72--Chepachet Village Antiques

Blackstone Valley River Explorer--50
Twin River Casino--27
Sunset Stables--43
2--Slater Mill
71--McCoy Stadium
93--Sky Zone Trampoline
Providence (see insert)
44--East Bay Bike Path

Lang's Bowlarama--66
Betty's Candies--45

Macomber's Blueberry Farm--8

Pawtuxet Village--22

86--Claire D. McIntosh Wildlife Refuge
85--Quito's Restaurant
Judge Roy Bean Saloon--29 64--America's Cup Hall of Fame
20--Coggeshall Farm
Blithewold--99

Arielle Arts--73

91--Green Animals Topiary
34--Prescott Farm
98--Gray's Ice Cream
74--Skydive Newport & 81--Bird's Eye View Helicopters

Wickford Village--53
End-O-Main Lobsters--3 Newport Polo--78
Gilbert Stuart Birthplace--46 47--Jamestown Windmill
Dutch Island Lighthouse--4

Newport (see insert)
19--Norman Bird Sanctuary
24--Sakonnet Vineyards

Jamestown Harbor--13
Narrow River Kayaks--58
Beavertail Lighthouse--4

75--Adventureland
89--Narragansett Town Beach

Grey Sail Brewery--36
Fantastic Umbrella Factory--77
21--Theater by the Sea
30--Narragansett Indian Church Grounds
Hermit Crab Races--97 38--Misquamicut Beach
Flying Horses Carousel--8 80--Blues on the Beach
Watch Hill Cove--13 14--Ocean House

Block Island (see insert)

0 5 10 20 Miles

14

PROVIDENCE

(Across the river in East Providence)

Thayer Street--61
Avon Cinema--40
Providence Ghost Tour--76
Prospect Terrace Park--41

Fed Hill--6
Julians Restaurant--16
Rooftop at ProvidenceG--60

18--La Gondola
79--Haven Bros Food Truck
7--Big Nazo Lab
59--PPAC Theater

Dean Hotel--63 82--Downcity District
CAV Restaurant--5 54--Arcade Providence

RISD Museum--55
WW II Memorial Park--48
Cable Car Cinema--40

Providence Flea--87

49--Roger Williams Park Zoo

28--Roger Williams Carousel

NEWPORT

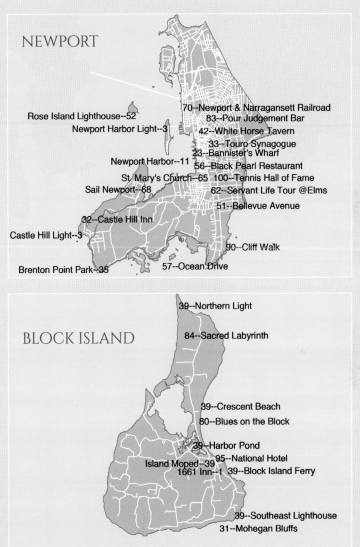

Rose Island Lighthouse--52
Newport Harbor Light--3

70--Newport & Narragansett Railroad
83--Pour Judgement Bar
42--White Horse Tavern
33--Touro Synagogue
23--Bannister's Wharf

Newport Harbor--11
St. Mary's Church--65
Sail Newport--68

56--Black Pearl Restaurant
100--Tennis Hall of Fame
62--Servant Life Tour @Elms
51--Bellevue Avenue

32--Castle Hill Inn

Castle Hill Light--3

90--Cliff Walk

Brenton Point Park--35

57--Ocean Drive

BLOCK ISLAND

39--Northern Light

84--Sacred Labyrinth

39--Crescent Beach
80--Blues on the Block

39--Harbor Pond
95--National Hotel
Island Moped--39
1661 Inn--1 39--Block Island Ferry

39--Southeast Lighthouse
31--Mohegan Bluffs

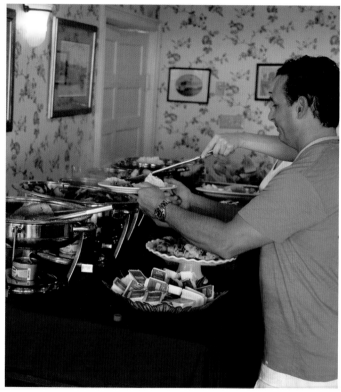

No. 1

Celebrate a new day with the champagne buffet breakfast at the quaint, oceanfront 1661 Inn on Block Island

The 1661 Inn
5 Spring Street, New Shoreham, Block Island | www.blockislandresorts.com

What a fantastic way to start your day! The lavish champagne buffet breakfasts at the oceanfront 1661 Inn are a Block Island tradition. Each morning the buffet features an array of dishes ranging from traditional baked bluefish to pancakes, waffles, fresh fruit, sausage, made-to-order omelets, homemade muffins, a large pastry selection, and so much more. Visit the champagne station and create your own mimosa. **Tip:** Ask to be seated on the outside lower level. It's so charming and romantic.

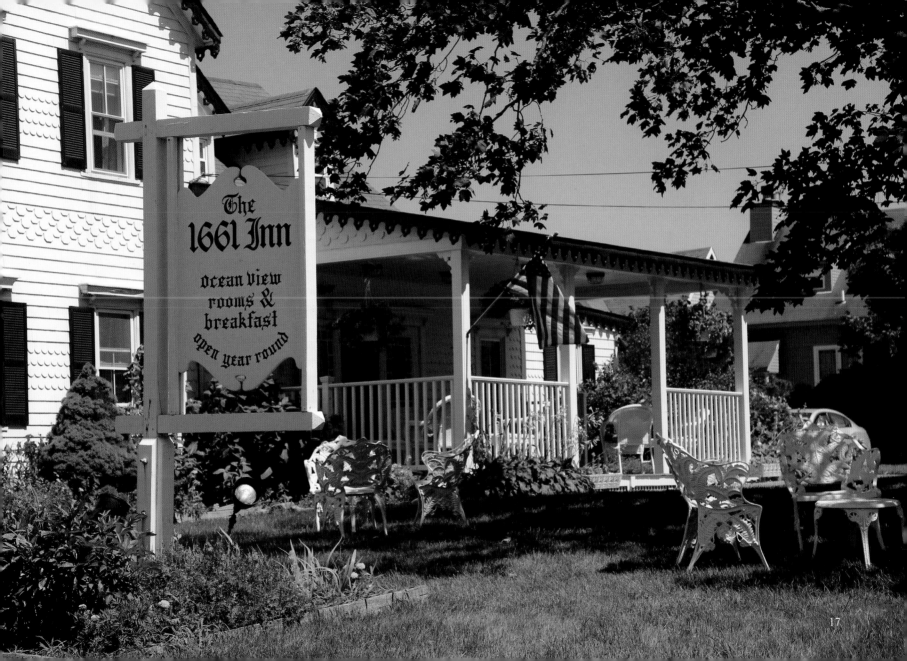

The
1661 Inn

ocean view
rooms &
breakfast

open year round

No. 2

Tour the first cotton-spinning factory in America at Slater Mill, considered the "Birthplace of the American Industrial Revolution"

Slater Mill
67 Roosevelt Avenue, Pawtucket | www.slatermill.org

Beautifully situated right alongside the Blackstone River in Pawtucket is Samuel Slater's original water-powered cotton mill. Built in 1793, the mill successfully produced the country's first machine-spun cotton thread. Because of his success, numerous mills were developed nearby that copied Slater's style and thus the Industrial Revolution was born. The well-maintained grounds also include the Wilkinson Mill, the Sylvanus Brown Cottage, a lovely garden, and a resplendent view of the mighty Blackstone River.

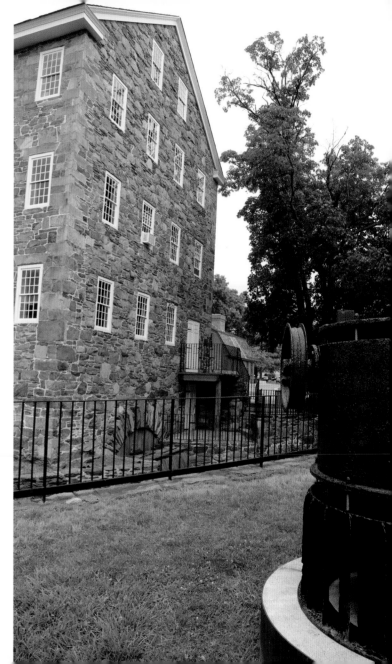

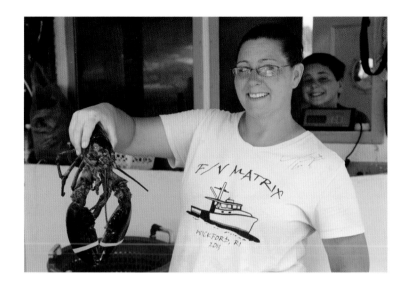

No. 3

Buy freshly caught lobsters right from the boat at End-O-Main Lobster on Wickford Town Dock

End-O-Main Lobster
Town dock at the end of Main Street, Wickford
www.endomainlobster.com

You can't really find lobsters much fresher or affordable than this! Captain Trip Whilden has been a commercial fisherman for twenty-eight years, and he traps 'em right here in Rhode Island and sells 'em from a large tank right on his fishing boat. Just drive to the dock at the end of Main Street in the quaint village of Wickford, jump on the boat, and then pick 'em live, clean 'em and cook 'em. Not only will you have a lot of fun, but you'll be supporting the hard-working local fishing industry. So go get 'em!

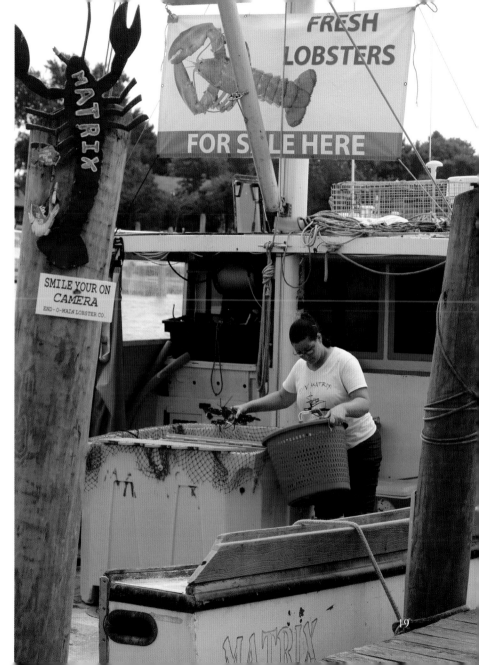

No. 4

Take a lighthouse cruise and get an eagle-eye view of the majestic lighthouses of Rhode Island

Newport Harbor Light
Goat Island, Newport
www.lighthousefriends.com

The picturesque granite Newport Harbor Lighthouse is neatly tucked behind the Hyatt Regency Newport Hotel on the northern end of Goat Island, which is officially a part of Newport. Built in 1842, the thirty-foot-tall structure is also known locally as the Goat Island Lighthouse (the official Goat Island Lighthouse is actually in Maine). The well-maintained grounds around the lighthouse are open to the public, but the tower itself is currently closed.

Dutch Island Light
Dutch Island, Narragansett Bay
www.dutchislandlighthouse.org

The noble forty-two-foot Dutch Island Lighthouse stands on the southern tip of small, rocky Dutch Island off the coast of Jamestown in Narragansett Bay. It's best viewed from the water, but there is a pretty good view from Fort Getty in Jamestown. The tower, which includes a four-room Keeper's House, was built in 1857. It replaced the original tower that was constructed in 1826. The grounds and the tower are closed, but preserved by the Dutch Island Lighthouse Society.

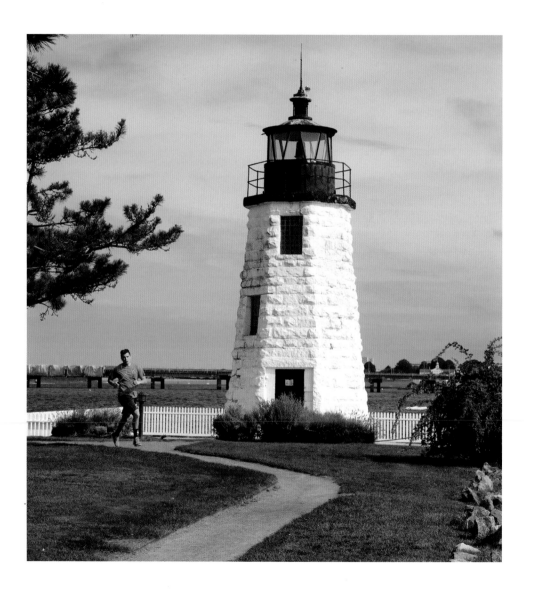

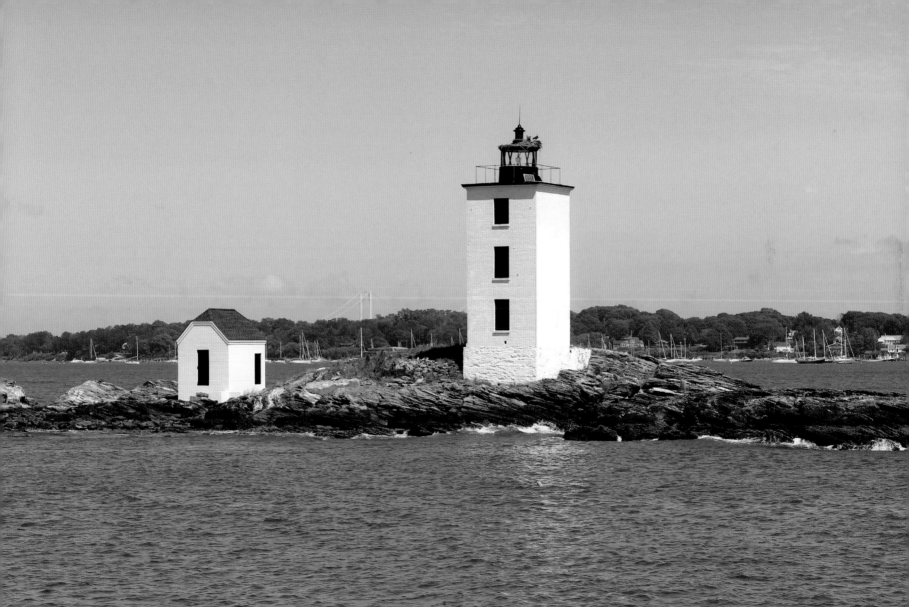

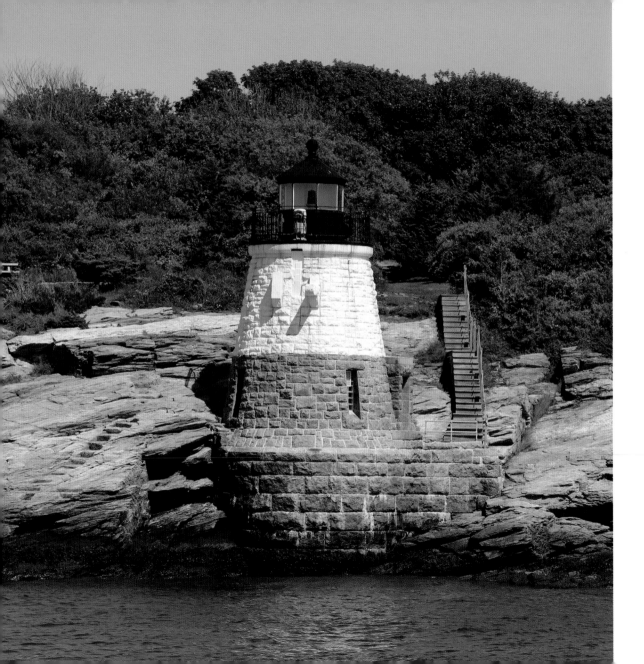

Castle Hill Lighthouse
East Passage of Narragansett Bay, Newport
www.lighthousefriends.com

Castle Hill Lighthouse is one of a number of navigational aids still serving ship traffic bound for Newport or Providence via the East Passage of Narragansett Bay. Built right into the rocky cliff face, the thirty-four-foot granite tower was constructed in 1890 and almost appears as a natural feature of the landscape. Its flashing red light has been used countless times as a beginning and ending point for Newport's famous yacht races. The lighthouse itself is closed, but the grounds adjacent to the Castle Hill Inn are open to the public. **Tip:** There's a little picnic table right beside the tower, so bring a lunch!

Beavertail Lighthouse
Southern tip of Conanicut Island,
Jamestown
www.beavertaillight.org

The premier lighthouse in all of Rhode Island is the sixty-four-foot-tall Beavertail Lighthouse. It stands on the rocky, windswept, southern point of Conanicut Island in Beavertail State Park, and it marks the entrance to Narragansett Bay from the mighty Atlantic Ocean. The site was originally established in 1749, making Beavertail the third oldest lighthouse in America. There's a really neat museum and a gift shop on the grounds and the tower is open to the public, so you can make the short climb to the top. If you only have time to visit one lighthouse, this would be the one!

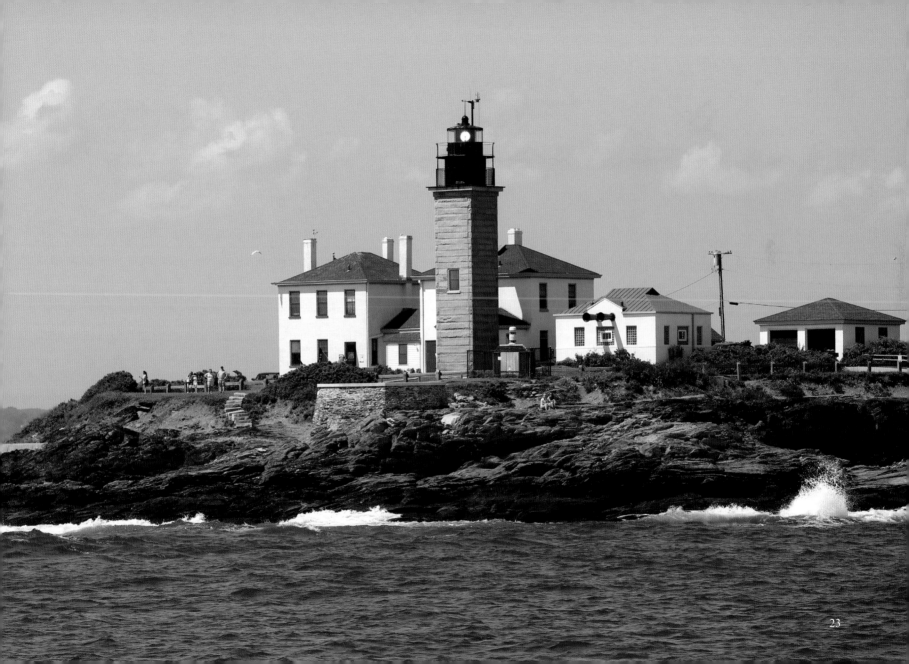

No. 5

Admire the authentic African art and enjoy the calamari at CAV, one of Providence's landmark restaurants

CAV Restaurant
14 Imperial Place, Providence | www.cavrestaurant.com

Quietly tucked away at the end of a pleasant courtyard in the heart of the Jewelry District is where you will find CAV Restaurant, one of Rhode Island's hidden treasures. This magical restaurant with award-winning food is lovingly filled with antiques and artifacts from around the world. Owner Sylvia Moubayed has been a collector of these fascinating objets d'art since the '60s, and her cuisine and atmosphere will surely restore your spirit. Even the nineteenth-century mahogany bar is an antique, as it was purchased from Pete's Tavern, the oldest bar in New York City.

No. 6

Hang out around the fountain in DePasquale Square in Federal Hill and pretend you're in Italy

DePasquale Square
Atwells Avenue, Federal Hill, Providence | www.federalhillprov.com

Filled with white tablecloths, lots of flower pots, and a charming Old World fountain, DePasquale Square is the heart of popular Federal Hill. Known as the "Little Italy" of Providence, the cobblestoned square is surrounded by Italian bakeries, restaurants, galleries, and plenty of quaint little stores for shopping and browsing. **Tip:** Wednesday evenings in the summer are a great time to grab some pasta and a glass of wine or an espresso as live music and big crowds fill the square.

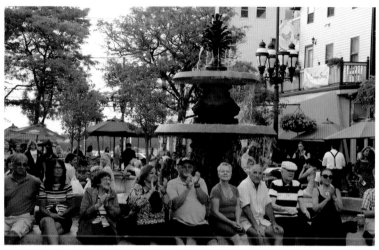

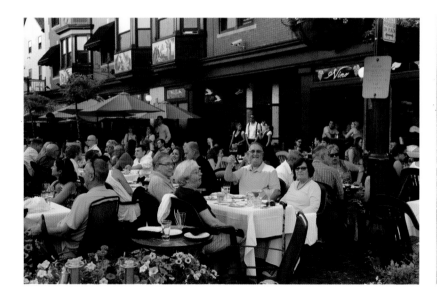

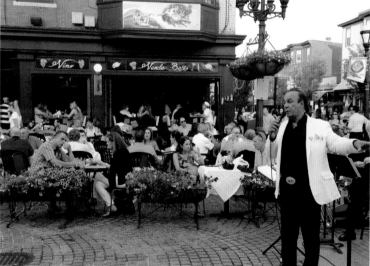

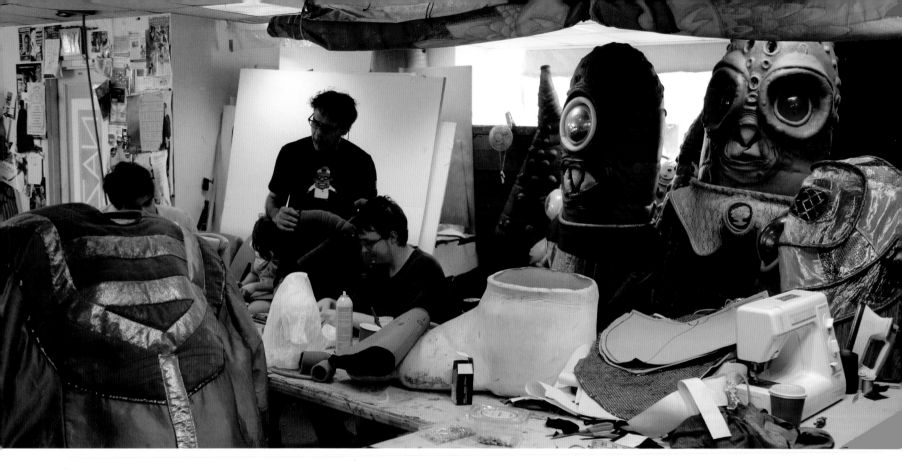

No. 7

Pop in to the workspace of the bizarre
and hilarious larger-than-life characters
created at Big Nazo Lab

Big Nazo Lab
60 Eddy Street, Providence | www.bignazo.com

Big Nazo is an international performance group of visual artists, puppet performers, and masked musicians who unite to create bizarre and hilarious larger-than-life-sized characters, environments, and spectacles. Their storefront across from City Hall in Providence acts as an exhibition space and a wild creature–building workshop. Check out the huge windows filled with colorful galactic monsters and hilarious mountain trolls, then bop inside and the friendly staff will show you how they make their magic. It's a fantastic place to take the kids!

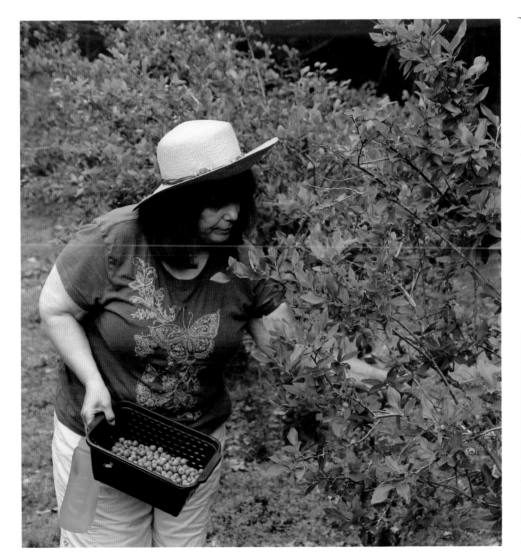

No. 8

Pick your own blueberries right off the bush at Macomber's Blueberry Farm

Macomber's Blueberry Farm
141 Rice City Road, Coventry
www.macombersblueberryfarm.shutterfly.com

Founded in 1985, Macomber's Blueberry Farm is a lovely two-acre spot in the far woods of Western Coventry. It's owned and operated by the welcoming and helpful John Macomber and his family, whose charming pick-your-own blueberry farm has grown to be a local icon. John produces several varieties of delicious blueberries, as well as garlic and other vegetables. He'll meet you with a smile, and point you in the best direction for finding the bushes with the plumpest and juiciest fruit. So grab a basket, climb under the netting (it keeps out the hungry birds!), and get a pickin'.

No. 9

Dig into a beloved Rhode Island tradition, a classic old-fashioned New England clambake

B&M Clambakes
560 York Avenue, Pawtucket
www.clambakeco.com

New England is known for a lot of things, but some of the most endearing to the locals here are summertime clambakes. Prepare your feast in an open beach pit (where permitted) or steam your meal in a giant stainless-steel pot. Make sure to have plenty of lobsters, mussels, steamers, quahogs, red bliss potatoes, corn-on-the-cob, and fresh seaweed to help with the steaming. You can do it all yourself, or call B&M Clambakes and they'll set it up for you!

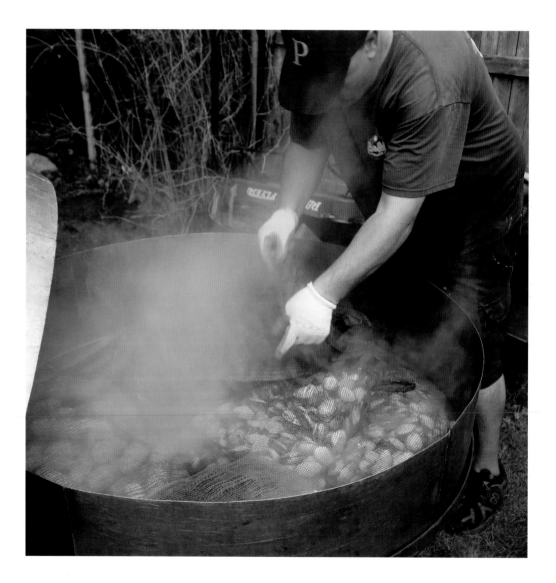

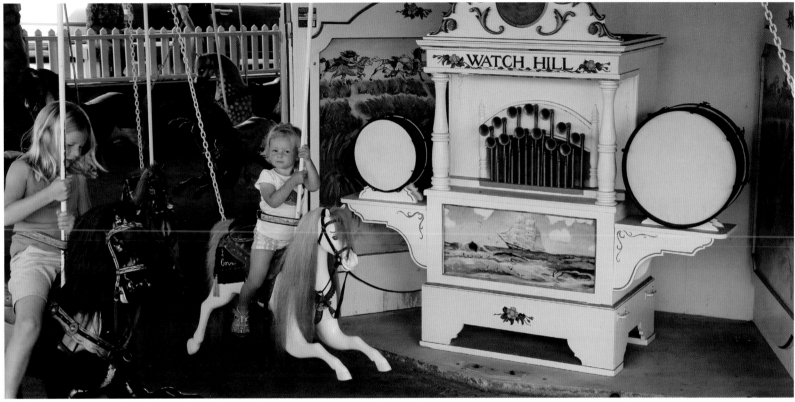

No. 10

Ride the Flying Horses Carousel in Watch Hill, believed to be the oldest carousel of its type in America

Flying Horses Carousel
151 Bay Street, Watch Hill | 401-348-6007

In a wood-framed pavilion next to the beach and across the street from an ice cream shop, you will find the historic Flying Horses Carousel of Watch Hill. Believed to be built around 1876 and used by a traveling carnival, the delightful wood-carved horses of the carousel are suspended by chains from sweeps radiating from the center. Look mom, no platform! Sorry to say, but only children under five feet and under 100 pounds can ride the ponies.

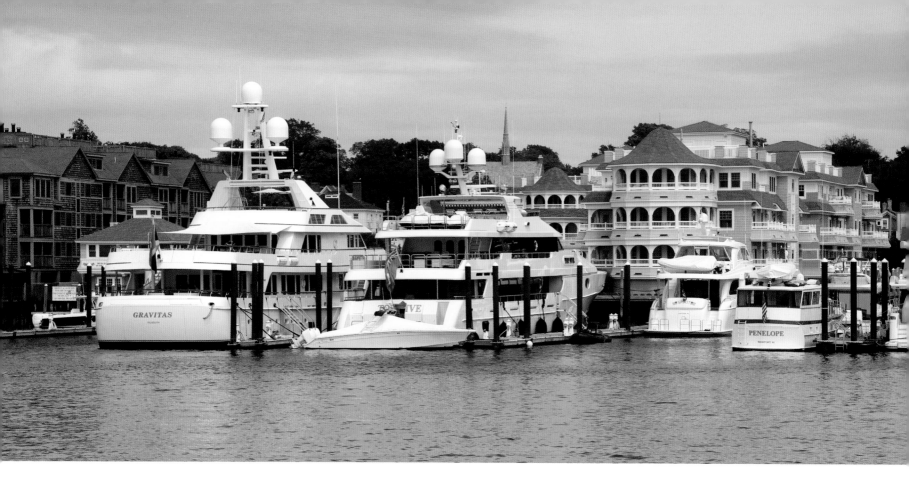

No. 11

Check out all the huge, multi-million dollar megayachts docked in Newport Harbor

Yachts docked in the harbor
Newport Harbor, Newport

Newport Harbor is one of the premier yachting destinations in the world. Recognized as "America's Sailing Capital," the harbor is breathtakingly filled with sailboats and luxury yachts owned by some of the richest people on the planet. Offering direct access to the Atlantic Ocean, the harbor teems with boating activities and world-class regattas. It is also home to the legendary America's Cup and her famous racing yachts.

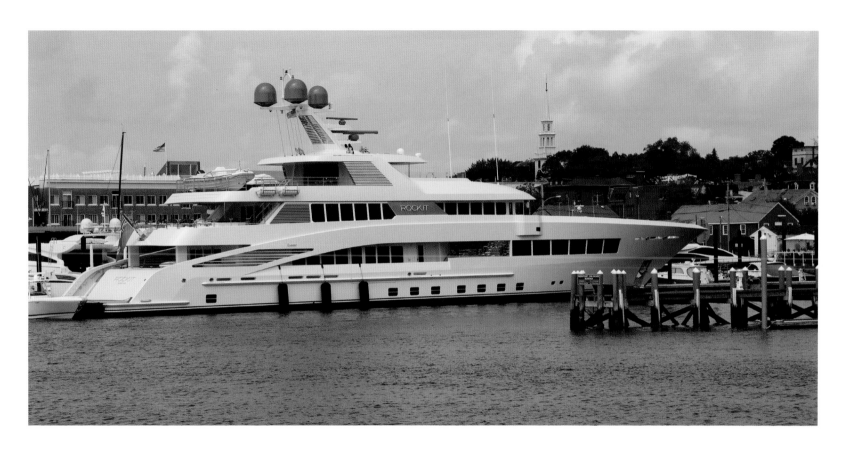

ROCK.IT Megayacht
Newport Harbor, Newport

Wow! Walk around the harbor in Newport and you're bound to see many privately owned super-yachts, such as ROCK.IT, which was custom-built for a private owner in 2014 by a Dutch manufacturer. The yacht has a sleek space-age look with deluxe accommodations for up to ten guests in five elegant private suites, including the owner's generous stateroom. One of the most striking features is the skylight in the sun deck canopy, which dims automatically depending on the strength of the sunlight. Rock on!

No. 12

Be inspired by the unique, handmade pieces available at the Field of Artisans, a weekly arts marketplace

Field of Artisans
Various locations throughout Rhode Island | www.fieldofartisans.com

Field of Artisans is an original collaborative of emerging artists, photographers, painters, designers, yogis, and musicians who come together every weekend at different locations to create and sell their unique handmade pieces. On any given weekend you might find an artisan giving a class, a musician trying out new material, or local artists collaborating on the spot to create a masterpiece. To really get the pulse of the current Rhode Island artisan community, you've got to check out Field of Artisans.

No. 13

Grab a camera and tour the many picturesque harbors throughout the Ocean State

Jamestown Harbor
End of Narragansett Avenue, Jamestown

The alluring Jamestown Harbor can be found by following Narragansett Avenue all the way down to the water of lower Narragansett Bay. You could consider Jamestown Harbor to be the quieter alternative to the busy, bustling harbor across the bay in Newport; the two are conveniently connected via the Jamestown Newport Ferry. The picturesque harbor is framed in by the grand Claiborne Pell Newport Bridge.

Harbor in Watch Hill Cove
Across from Bay Street, Westerly

This gentle harbor is nestled along the shore of Block Island Sound in the far southwest corner of Rhode Island. The harbor itself is situated on the backside of a peninsula that is nearly surrounded by the ocean, which adds to the beauty of the entire Watch Hill vicinity. The area immediately around the harbor is filled with local shops, fine restaurants, and picturesque beachfront homes.

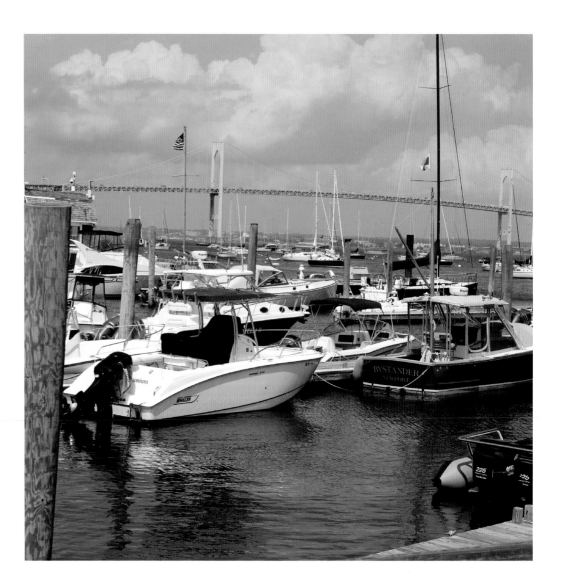

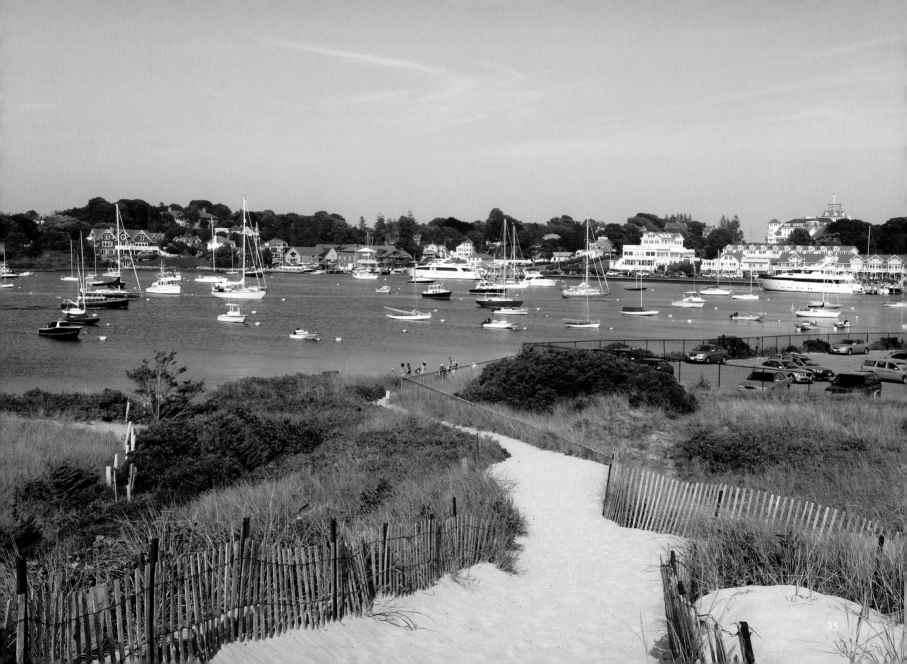

Wickford Cove
Behind Brown Street or Main Street, North Kingston

Known as one of the best harbors in Narragansett Bay, this relaxed cove is surrounded by historic Wickford Village, a small hamlet that offers a taste of New England life as it was centuries ago. The entire Wickford Harbor waterfront is dotted with eighteenth-century homes, churches, quaint little shops, restaurants, and beautifully appointed gardens.

Tip: A great way to enjoy the harbor would be to rent a kayak from the Kayak Center near Hussey Bridge. You can easily paddle your way around the entire cove.

No. 14

Take a croquet lesson or attend teatime at the magnificent Ocean House, "the last of the grand Victorian hotels"

Ocean House
1 Bluff Avenue, Watch Hill | www.oceanhouseri.com

Perched high on the bluffs overlooking the Atlantic, the iconic Ocean House is one of Rhode Island's finest upscale resorts. Dating from 1868, it's the first Rhode Island establishment to be honored with the prestigious Five Diamond Lodging award. Take part in their tranquil teatime, order one of their legendary cocktails, stroll on their 650-foot private white-sand beach, or play a game of croquet on the beautifully manicured championship croquet lawn, and you'll know why they call this oceanfront gem "the last of the grand Victorian hotels."

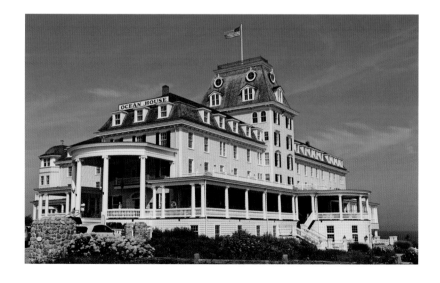

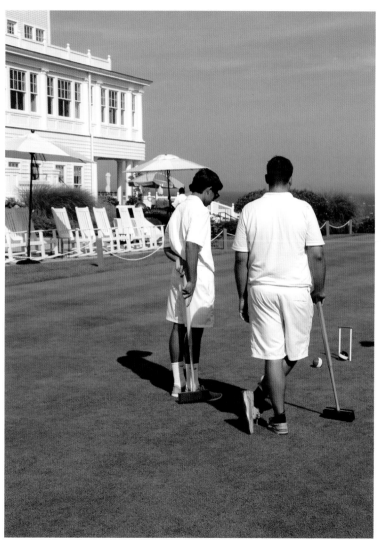

No. 15

Enjoy one of the truly great original Rhode Island summer pleasures: a classic frozen lemonade from Del's

Del's Frozen Lemonade
Stores, carts, stands and trucks throughout Rhode Island | www.dels.com

The frozen lemonade that started out in a little storefront in Cranston has grown to become Rhode Island's famous signature drink. Del's frozen lemonade is so refreshing—slightly tangy, and just a little bit sweet. You can find the popular frozen fruit ices virtually everywhere in Rhode Island; at their stores, at roadside carts and trucks, or at portable stands scattered throughout parks and street corners. And the lemonade is served with a pretzel stick . . . how delightful!

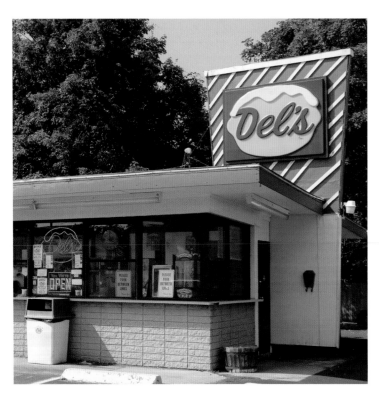
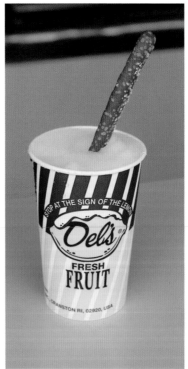
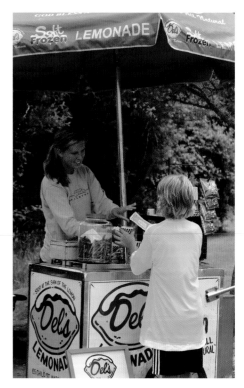

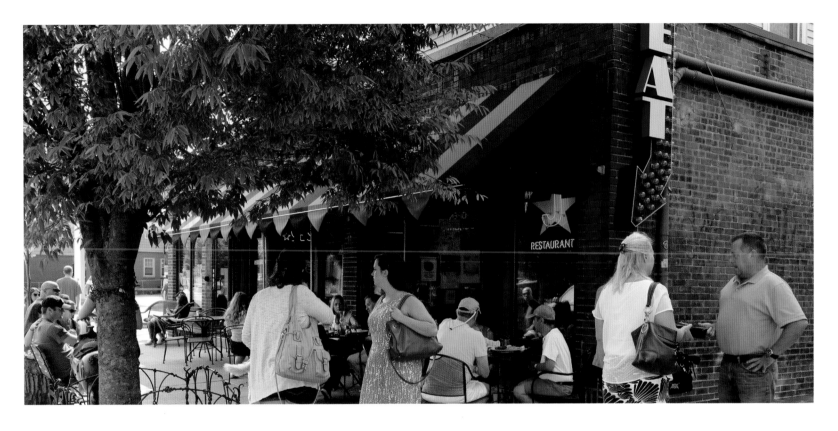

No. 16

Join the hipster crowd for a fabulous brunch at Julian's, a local favorite

Julian's
318 Broadway, Providence | www.juliansprovidence.com

The people of Providence love to do brunch. And one spot that is near the top of everyone's list is Julian's, a brewpub that is just a short drive down Broadway from the city center. The atmosphere here is pure hipster, and the menu is pure brunch heaven. They've got awesome vegan options, as well as a healthy selection of omelets with names like "Thee Weeping Toreador" and "The Jedi Mind Trick." Check out the fantastic Pez dispenser collection in the washroom!

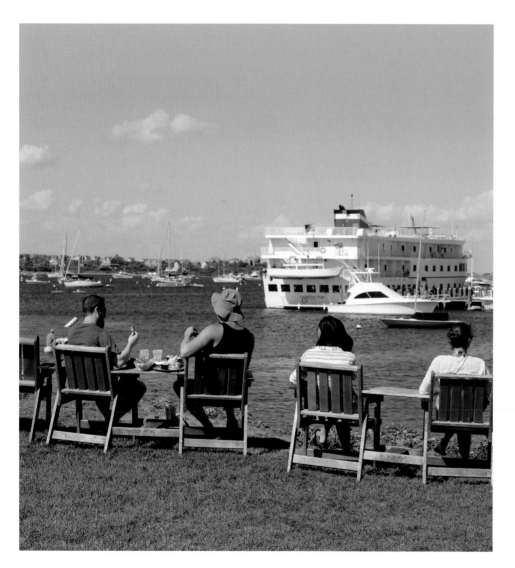

No. 17

Simply take a seat, grab a snack, and sit back and admire all the fantastic sailboats

Sailboat watching
The state's many harbors

Strolling the many historic villages and bustling harbors of Rhode Island could be a bit taxing on the feet. So thank God for the town parks, hotels, restaurants, community groups, and others who line the harbors and waterfronts with these delightful wooden chairs and tiny tables. Stop by a deli and grab a bite to eat and a cold beverage. Then just sit back by the waterside and enjoy the sailboats.

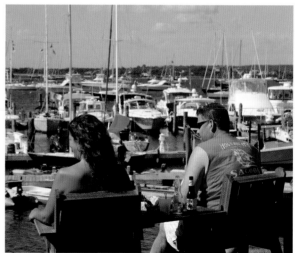

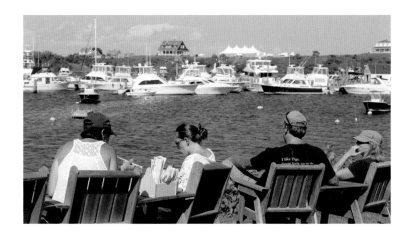

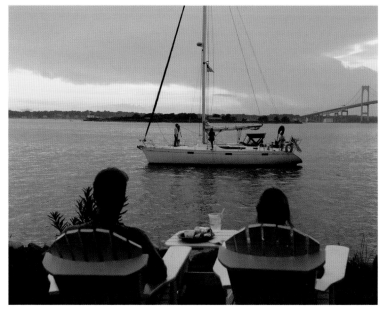

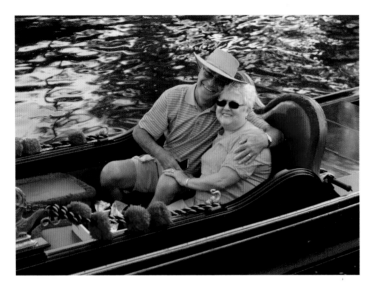

No. 18

Take a romantic ride through the heart of
Providence on an authentic Venetian gondola

La Gondola Providence
1 Citizens Plaza, Providence | www.gondolari.com

Now this is the way see to Providence! You'll get the most unforgettable
views of the city from a unique vantage point by taking an excursion in a
romantic Venetian gondola along the winding Providence River. Offered by
La Gondola, not only will your gondolier act as your personal guide, but he
just might serenade you as well. **Tip:** You can really ramp up the romance
on your trip by adding a live musician, handmade chocolates, wine biscuits,
or an ice bucket with two keepsake hand-painted wine glasses.

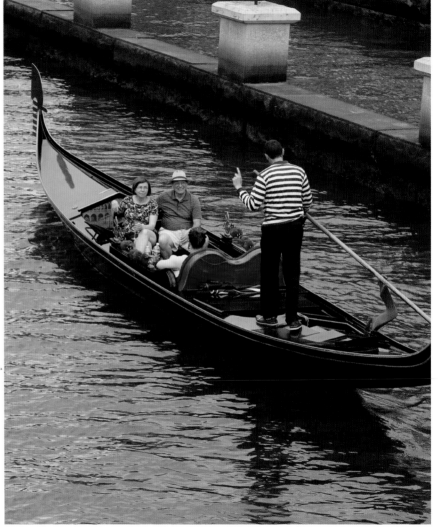

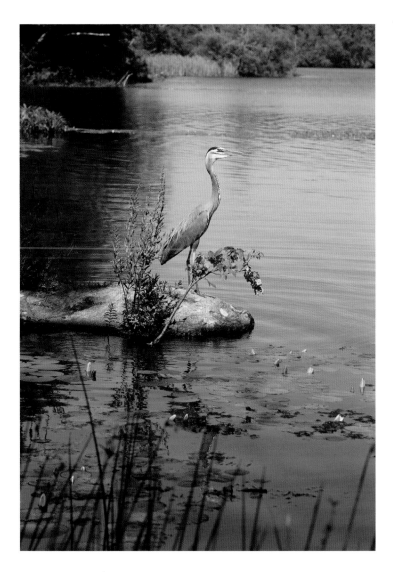

No. 19

Grab your binoculars and explore the wildlife along the pristine trails at the 325-acre Norman Bird Sanctuary

Norman Bird Sanctuary
583 Third Beach Road, Middletown | www.normanbirdsanctuary.org

One of the top places to observe warblers, swallows, migrating birds, and sea birds is the Norman Bird Sanctuary in Middletown. The 325-acre nature preserve features woodland, hay fields, seven miles of hiking trails, and lots of ridges overlooking the ocean. There's also a really neat nineteenth-century Barn Museum with wildlife and ecosystem exhibits. **Tip:** The sanctuary offers a two-hour guided bird walk every other Sunday. It's free for members, but you can join in for a small fee.

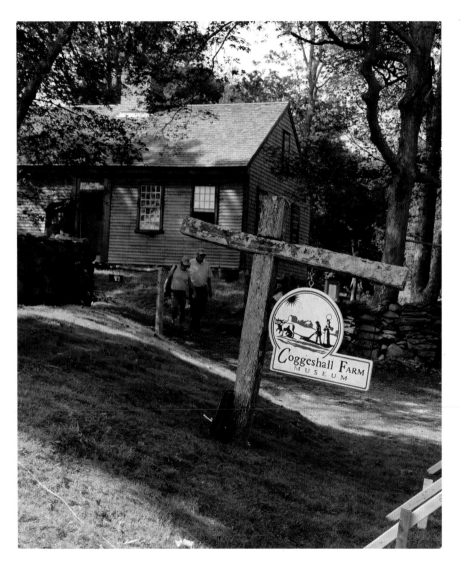

No. 20

Explore the lives of ordinary tenant farmers in 1799 at the Coggeshall Farm Museum

Coggeshall Farm Museum
1 Colt Drive, Bristol | www.coggeshallfarm.org

Take a step back in time and experience how middle-class families lived in the 1790s at the Coggeshall Farm Museum. This forty-eight-acre salt marsh farm is now a living history museum, with folks dressed in period clothing working in the original farmhouse, spring house, kitchen garden, barns, fields, and pastures. There are lots of daily demonstrations where you're encouraged to get your hands dirty by jumping in and helping to gather wood, collect eggs, cook over the hearth, make candles, or care for the animals.

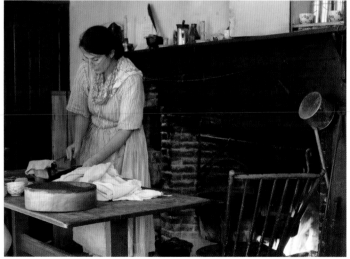

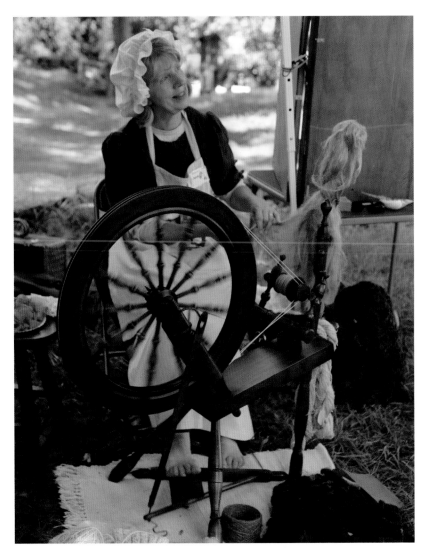

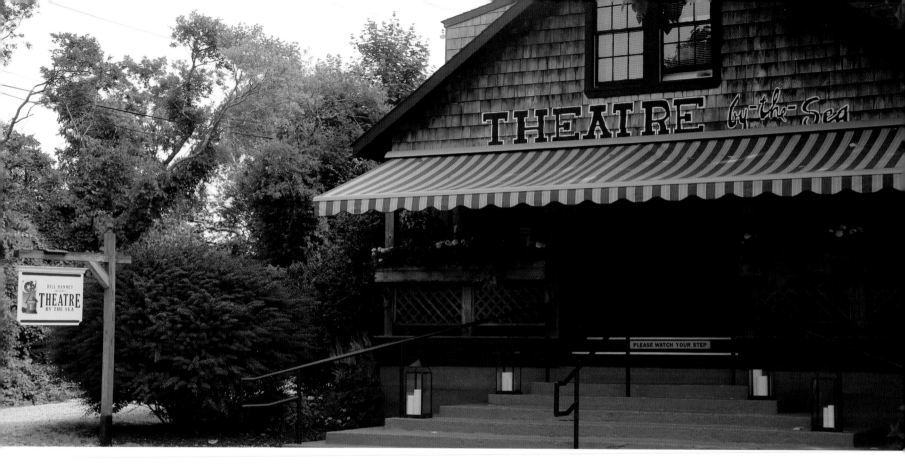

No. 21

Expose yourself to the full monty of a theatrical experience at the historic Theatre by the Sea

Theatre by the Sea
364 Cards Pond Road, Wakefield | www.theatrebythesea.biz

Founded in 1933, the Theatre by the Sea is a charming old performance hall offering professionally produced Broadway musicals. It's located in a converted rustic barn with a welcoming front porch filled with flower boxes. A little brick walkway leads to a beautifully landscaped garden with a gazebo—the perfect spot for a pre-theater beverage. The intimate performance hall is a cozy way to experience legendary Broadway shows like *Sister Act* or *West Side Story*.

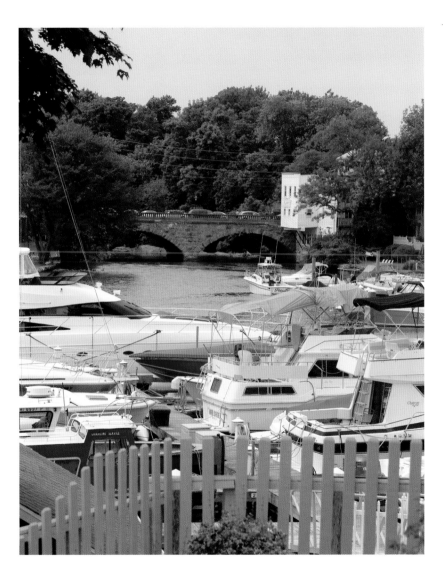

No. 22

Gallivant around the quaint shops, restaurants, and parks of Pawtuxet Village

Pawtuxet Village
Post Road and Narragansett Parkway, bordering Warwick and Cranston
www.pawtuxet.com

One of the oldest communities in New England, Pawtuxet was settled in 1638 by four English families. The village quickly grew to a thriving seaport by the 1700s with colonial, Greek revival, and Victorian homes. Located at the point where the Pawtuxet River empties into the Narragansett Bay, the quaint little town is a great way to spend an afternoon. There are lots of wonderful eateries, drinkeries, and places to go shopping.

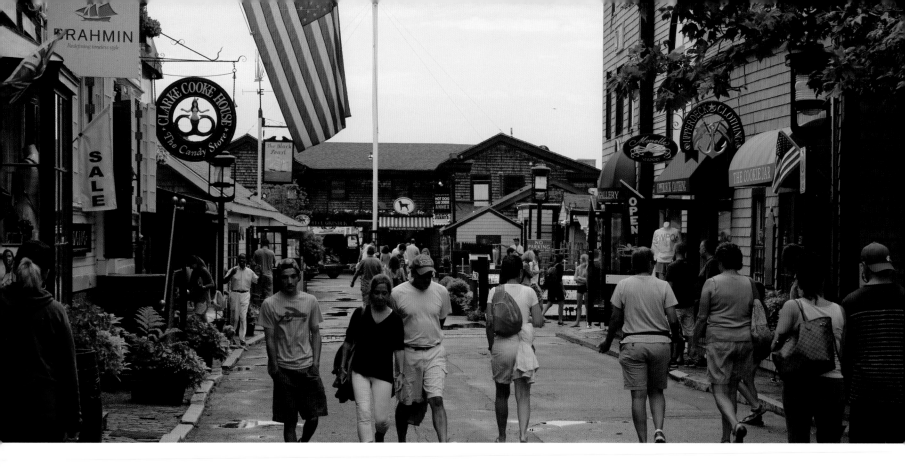

No. 23

Shop, dine, sail, and stroll
through historic Bannister's Wharf
on Newport's harbor front

Bannister's Wharf, Newport
www.bannistersnewport.com

Colorful Bannister's Wharf is the heartbeat of Newport's waterfront activities. Here you will find access to many of the best sailboat cruises, legendary restaurants like the Black Pearl, shopping, galleries, live music, and outstanding open-air bars and pubs. After the early morning delivery trucks have come and gone, the street fills with people wandering from America's Cup Avenue past the Black Dog General Store, and then out to Newport Harbor. When in Newport, it's not to be missed!

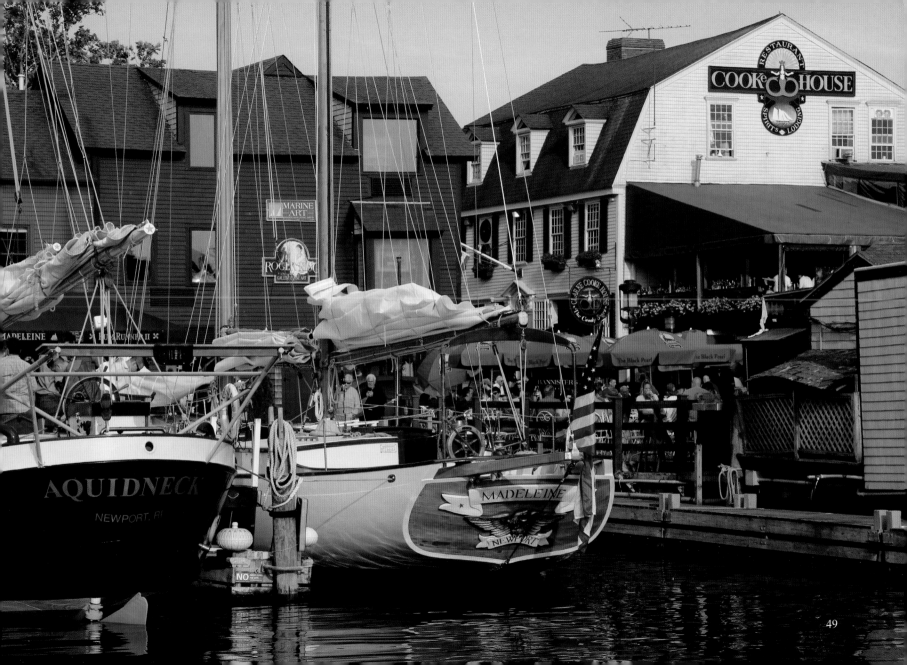

No. 24

Crack open a bottle of wine at a shaded table overlooking the spectacular grounds at Carolyn's Sakonnet Vineyard

Carolyn's Sakonnet Vineyard
162 West Main Road, Little Compton | www.sakonnetwine.com

What a great way to spend the afternoon! You can take a tour of the impressive vineyard grounds and wine cellar, sample wines in their tasting room, hang out with a glass of wine on the comfortable Adirondack chairs that are spread throughout the fields, or enjoy a bottle of wine and a cheese platter under an umbrella overlooking the rows of vines from the front lawn. Whichever you choose, you're sure to leave with a smile on your face.

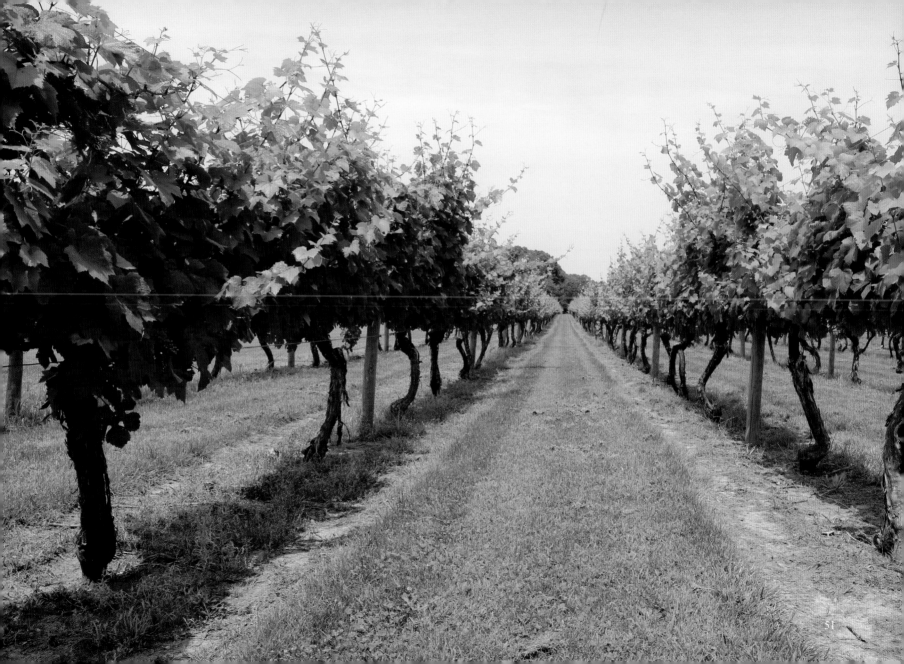

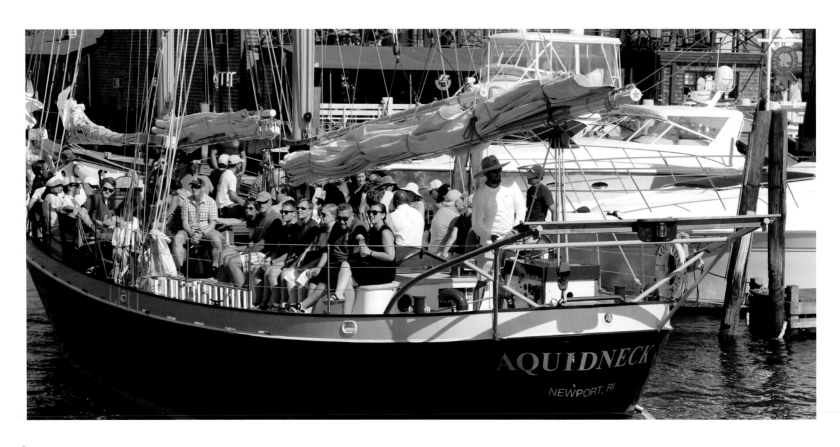

No. 25

Jump on an elegant, turn-of-the-century sailboat and head out for an unforgettable sunset cruise

Schooner Aquidneck
Bowen's Wharf, Newport | www.sightsailing.com/aquidneck.php

The romantic "sunset" cruise is one of the more popular cruises available from the docks on Bowen's Wharf. I suggest you make a reservation and hop aboard the schooner Aquidneck, an elegant eighty-foot-long sailboat with billowing sails and wood trim, to watch the twilight spectacle. She sails through one of the prettiest harbors in the world and out to Narragansett Bay, right along the shoreline of Newport's Ocean Drive. You can join in and help raise the sails as you head into the sunset!

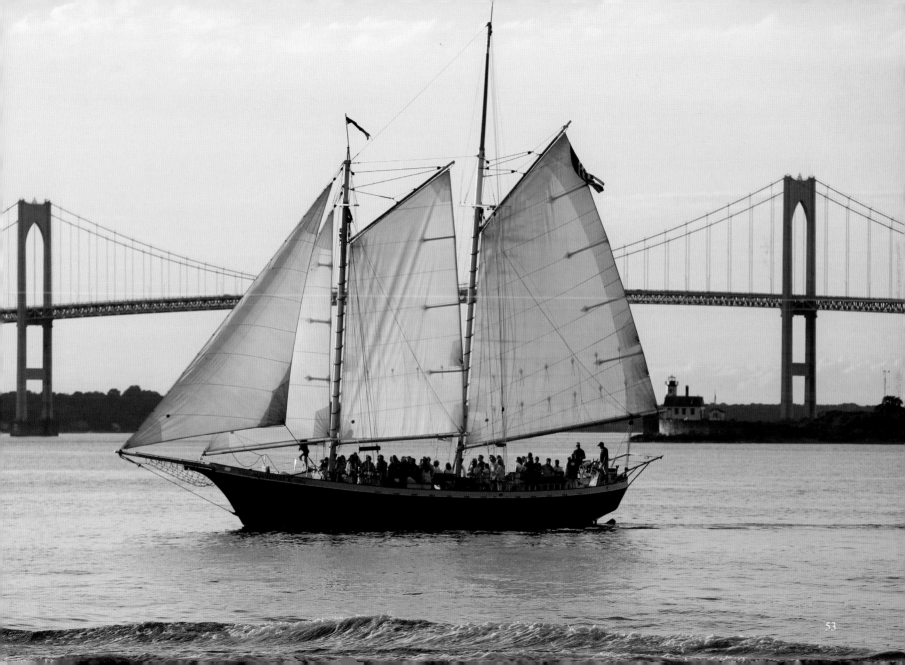

No. 26

Have an egg roll served-up with legendary jazz and blues acts at Chan's Fine Oriental Dining

Chan's Fine Oriental Dining
267 Main Street, Woonsocket | www.chanseggrollsandjazz.com

Dinner show with some of the best Chinese food around? You bet! Chan's Fine Oriental Dining is part restaurant, part jazz club, part art gallery, and part memorabilia exhibition. In other words, it's one of the coolest places in Rhode Island to get a great meal and watch live performances by masters of jazz, blues, folk, and cabaret. The ever-cordial owner John Chan will be glad to show you around and point out paintings, photographs, posters, and other keepsakes he has collected from the many world-class musicians who have played his sophisticated, legendary restaurant/nightclub. So grab an egg roll and enjoy the concert!

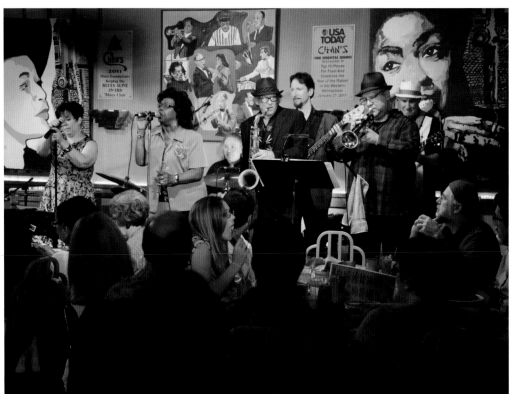

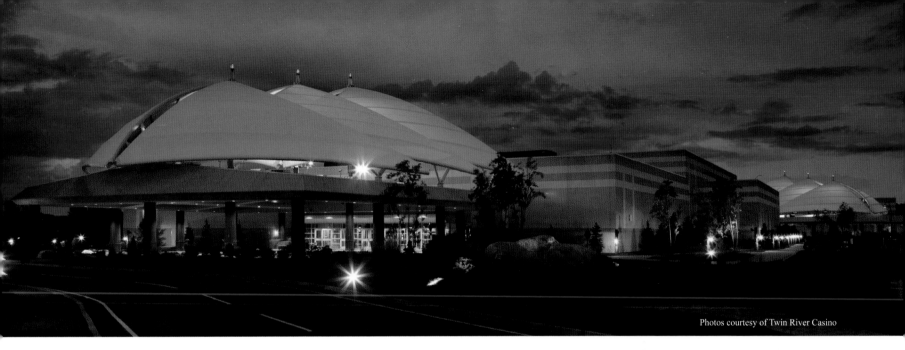

Photos courtesy of Twin River Casino

No. 27

Roll the dice, play the slots, grab a drink, and enjoy world-class entertainment at the spectacular Twin Rivers Casino

Twin River Casino
100 Twin River Road, Lincoln | www.twinriver.com

Just a ten-minute drive from Providence, the Twin River Casino is the place to play in Rhode Island. The mega-huge complex sparkles with slot machines, blackjack and roulette tables, a poker room, simulcast horse racing, and many other games of chance. There's also a huge live-entertainment theater for national acts, assorted restaurants and pubs, and even a popular cigar bar. It's a really lively way to spend the night, if you've got the extra cash! Good luck!

55

No. 28

Spend a relaxing afternoon riding the carousel and the swan paddleboats at Roger Williams Carousel Village

Carousel Village in Roger Williams Park
1000 Elmwood Avenue, Providence | www.rwpzoo.org/carousel

The entertaining Carousel Village is centrally located in Roger Williams Park, one of the most beautiful places in the state's capital city. The 435-acre public space, the "Central Park" of Providence, features over 100 acres of ponds weaving their way throughout the rolling landscape. Just south of the zoo near the park's boathouse, the village is a wonderful spot to ride a Victorian-style carousel, travel the pond in an entertaining swan paddleboat, jump on the children's trackless train ride, or stroll the Japanese gardens.

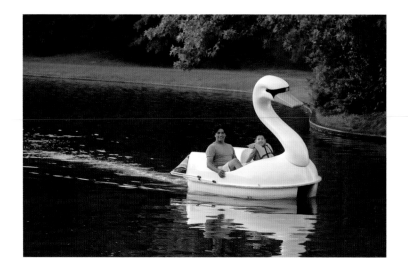

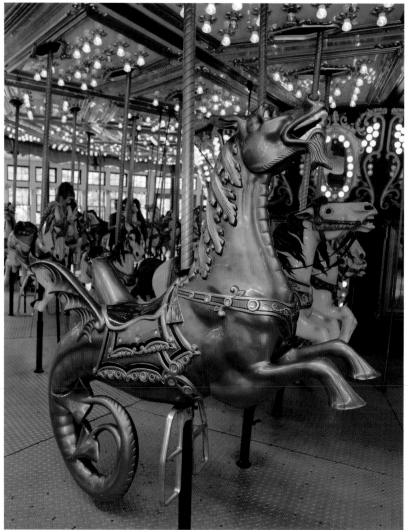

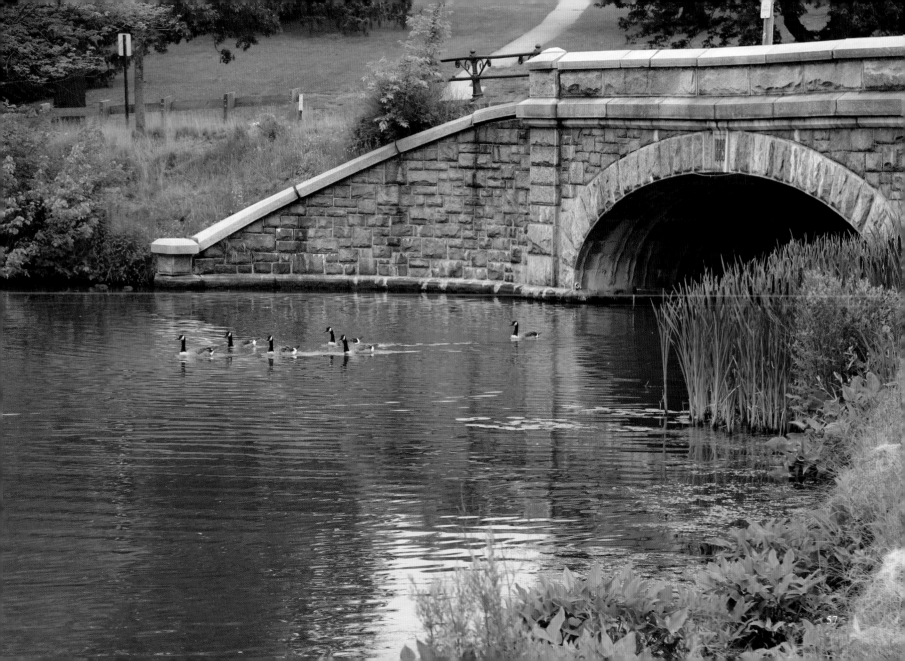

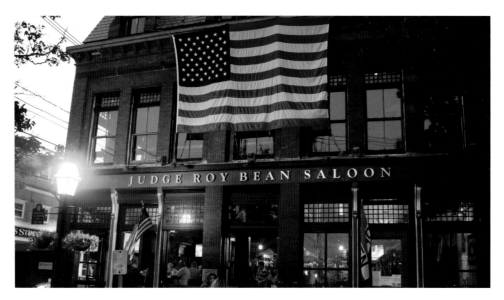

No. 29

Celebrate your independence at Judge Roy Bean Saloon
in Bristol, considered "America's Most Patriotic Town"

Judge Roy Bean Saloon
1 State Street, Bristol | www.jrbeansaloon.com

The city of Bristol paints the center lines of its main streets red, white, and blue; displays more flags
per capita than any other city; and hosts the longest running Independence Day parade in the country.
Yes, when you've entered Bristol, you have entered "America's Most Patriotic Town." And at the center
of it all stands Judge Roy Bean Saloon. Just a stone's throw from the harbor, this historic brick building
at the corner of State and Thames has huge front windows that open up to the street, a nostalgic mahogany
bar, and terrific gastropub fare. So go ahead and belly up to the bar for a cold one!

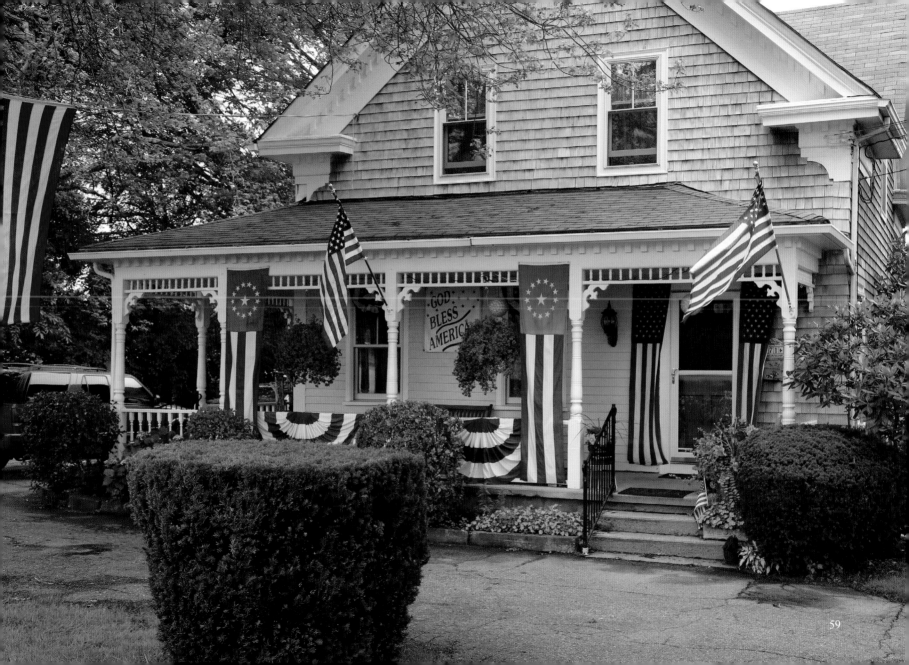

No. 30

Attend a festival or pow wow presented by the Narragansett Indian Tribe, Rhode Island's original inhabitants

Narragansett Indian Tribe Meeting & Pow Wow
Narragansett Indian Church Grounds, Charlestown | www.narragansett-tribe.org

The Narragansett Indians are descendants of the aboriginal people of the region dating back over 30,000 years. Today, there are about 2,400 members of this proud tribe—and their many festivals, celebrations, and pow wows are open to the public. It's a great opportunity to learn about the tribe's culture and customs, indulge in some homemade foods, marvel at the colorful costumes, and enjoy traditional music and dancing. The best part is you get to shake hands with some mighty nice folks.

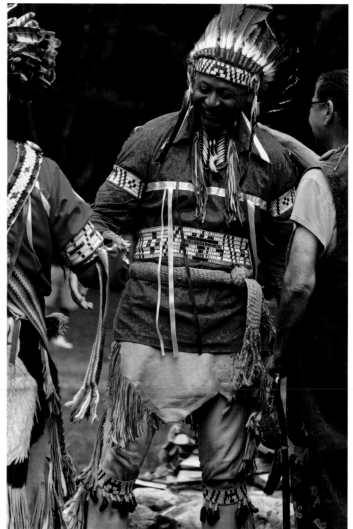

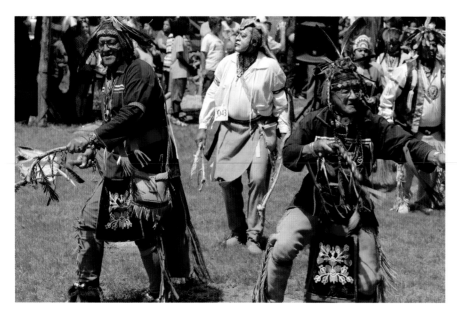

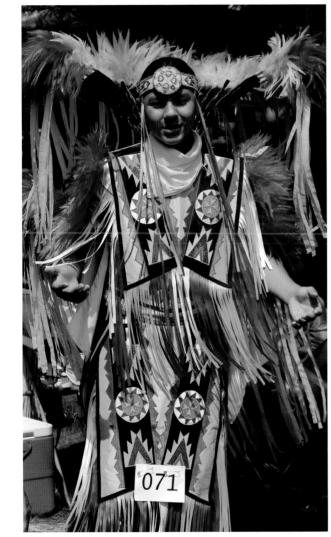

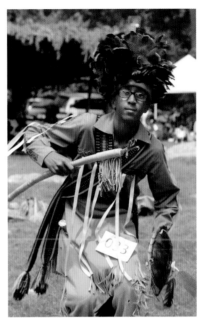

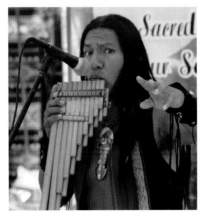

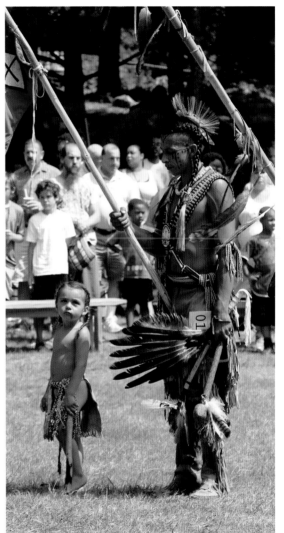

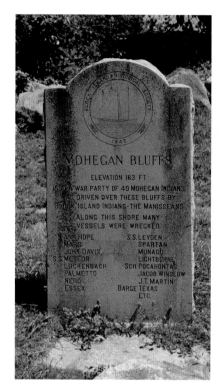

NO. 31

Scale the cliffs and enjoy the breathtaking views of Mohegan Bluffs on Block Island

Mohegan Bluffs
Off Mohegan Trail on the South Shore, Block Island

Of all the spectacular sights on this remarkable island, the breathtaking Mohegan Bluffs outshine them all. The large clay cliffs on the southern shore overlooking the vast Atlantic Ocean rise over 200 feet above the sea, and the views of the water and the unspoiled beach below will be the highlight of any visit. You can walk down the sturdy wooden staircase to a little viewing platform, but if you want to go all the way down to the beach, you have to transverse a steep, rocky slope. This slope might not be for everyone, but do attempt the staircase.

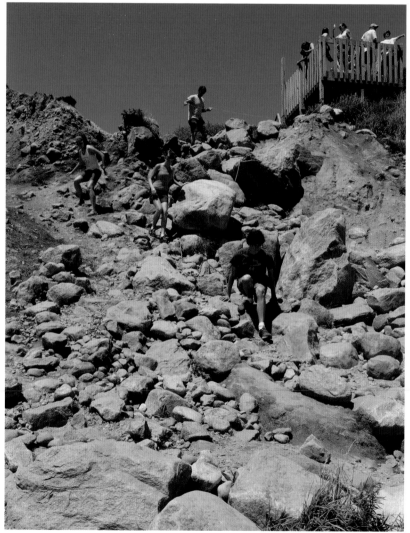

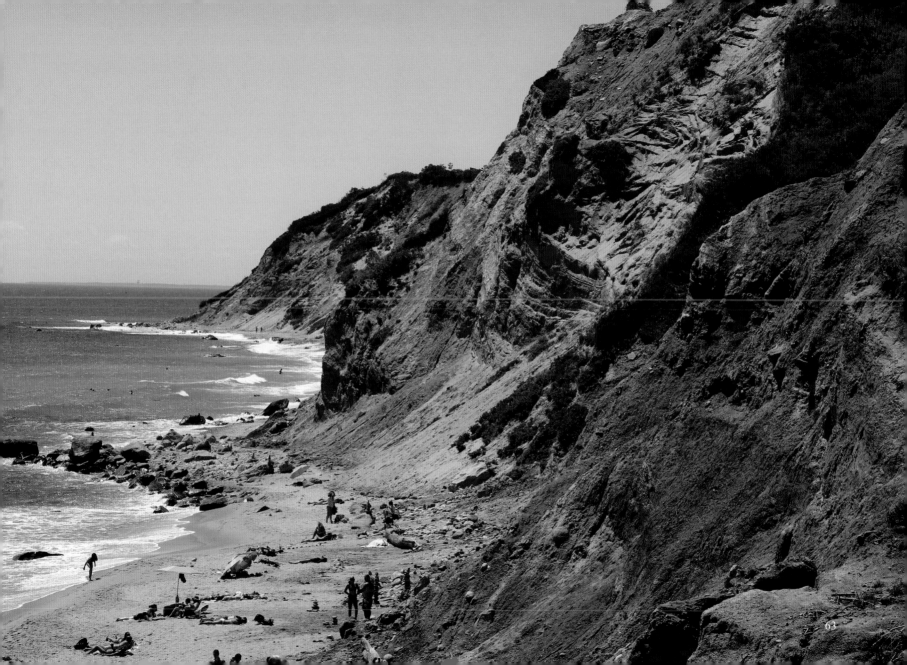

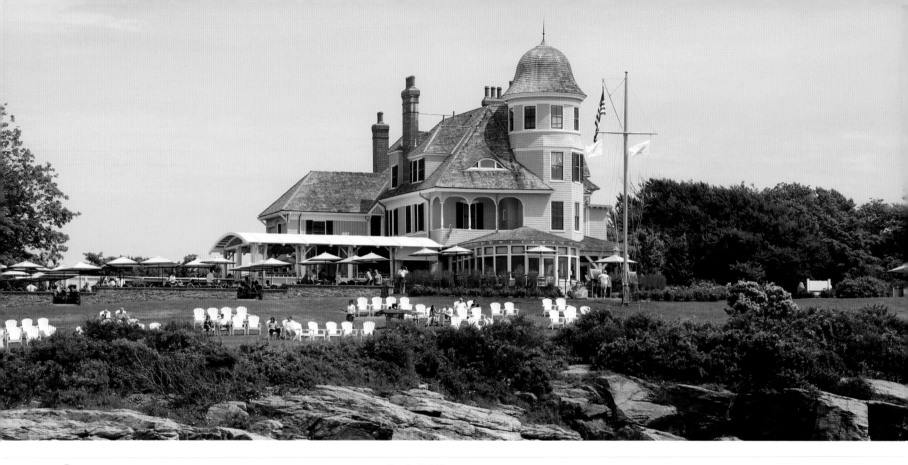

NO. 32

Sip on a martini in an Adirondack chair overlooking the Atlantic Ocean at the luxurious Castle Hill Inn

Castle Hill Inn
590 Ocean Avenue, Newport | www.castlehillinn.com

It's really hard to say which is more impressive, the luxurious Castle Hill Inn itself or the magnificent waterfront lawn that is right at the entrance of Narragansett Bay overlooking the East Passage and the Atlantic. I'm going with the lawn! Sit back in one of the Adirondack chairs and have the staff deliver small plates of seafood and cocktails right to your seat as you marvel at the sailboats. It's not required, but don't be afraid to wear something a little nice. The whole scene is so very Great Gatsby! **Tip:** Sneak down the little wooden staircase to the secluded rocky shoreline. It's the spot where Grace Kelly used to swim and sun in her off time when she was filming *High Society*.

NO. 33

Take an inspirational tour of Touro Synagogue, the oldest synagogue in America

Touro Synagogue
85 Touro Street, Newport | www.tourosynagogue.org

Touro Synagogue, founded in 1758, is the oldest Jewish synagogue building in the United States. Serving Congregation Jeshuat Israel, it is still an active house of worship. When the synagogue is not operating as a house of prayer, they do offer wonderful and informative guided tours. **Tip:** The tour also includes admission to the Ambassador John L. Loeb Jr. Visitors Center, which houses a monumental letter written by President George Washington to the Jews of Newport. Don't miss it.

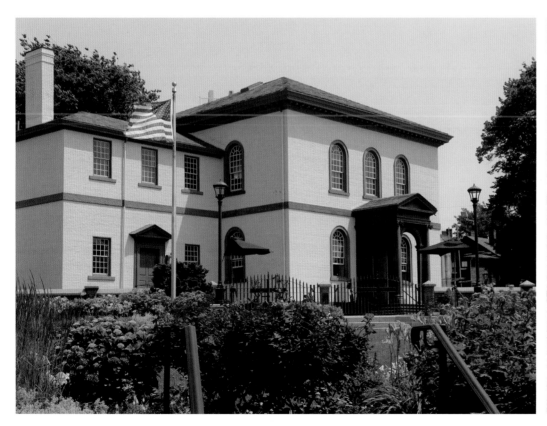
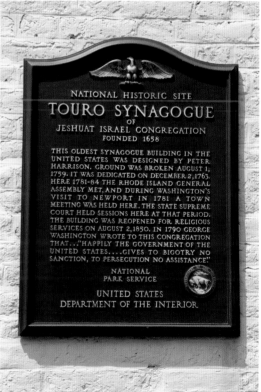

NO. 34

Feel history come alive in the charming country setting at Prescott Farm

Prescott Farm
2009 West Main Road, Middletown | 401-849-7300

Prescott Farm is a neat little green space rich in history with ties that go back to the Revolutionary War. The winding trails throughout the forty-acre farm will take you past historic eighteenth-century homes and cottages, a beautiful 1812 windmill, an outstanding herb garden carefully maintained by a master gardener, and a small pond inhabited by lots of ducks and geese. **Tip:** The best time to visit might be on Windmill Wednesdays, when the farm comes alive with music and johnnycakes.

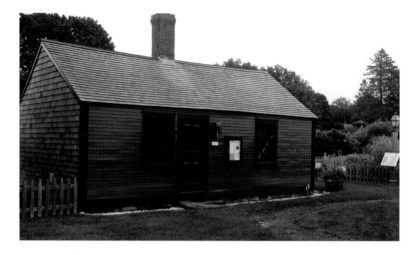

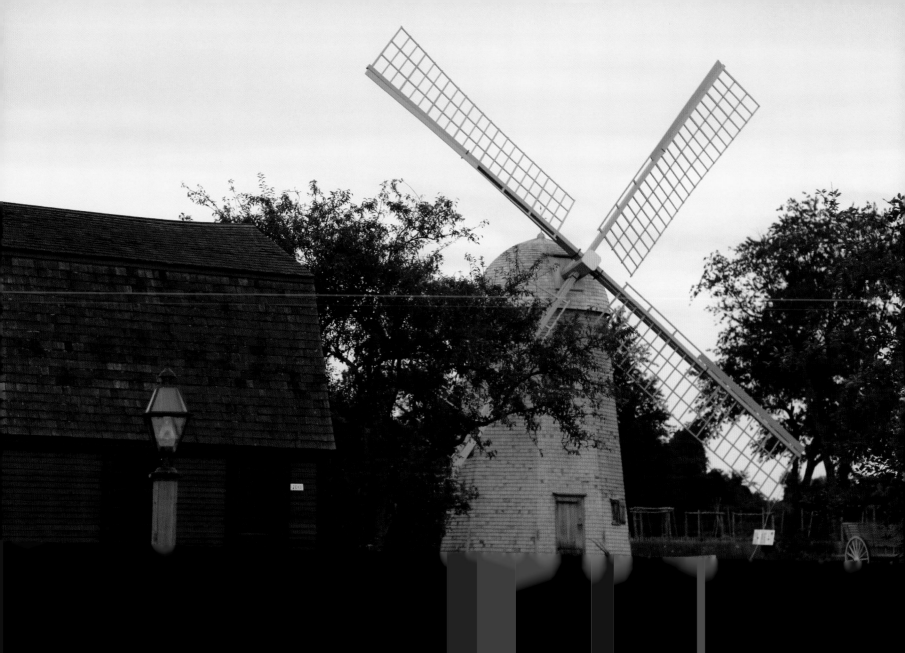

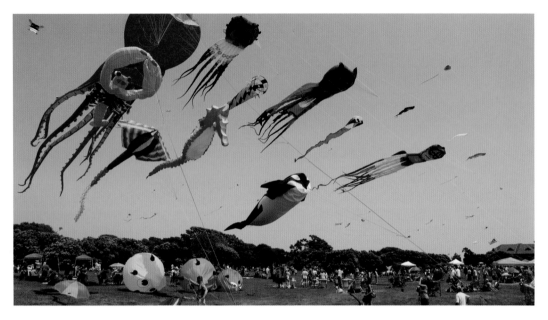

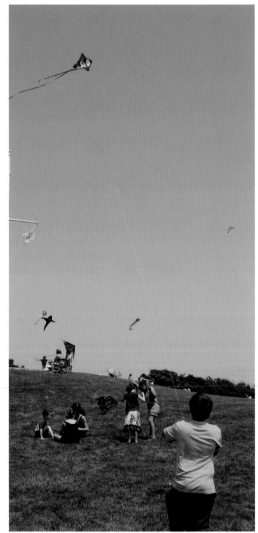

NO. 35
Grab a kite and some string and take advantage of the
ocean breeze at Brenton Point State Park

Newport Kite Festival
Brenton Point State Park, Newport | www.riparks.com

This is kite-flying paradise! Not only does Brenton Point State Park have an excellent oceanfront location, an assortment of beautiful gardens, lots of walking trails, and plenty of free parking, but it also has that wonderful, dependable ocean breeze. It's a great spot to take your kite any time of the year, but the best time would have to be during Newport's ultra-popular kite festival in July. You'll see everything from simple children's kites to giant character kites filling the sky with brilliant colors. Bring a lawn chair and enjoy the show!

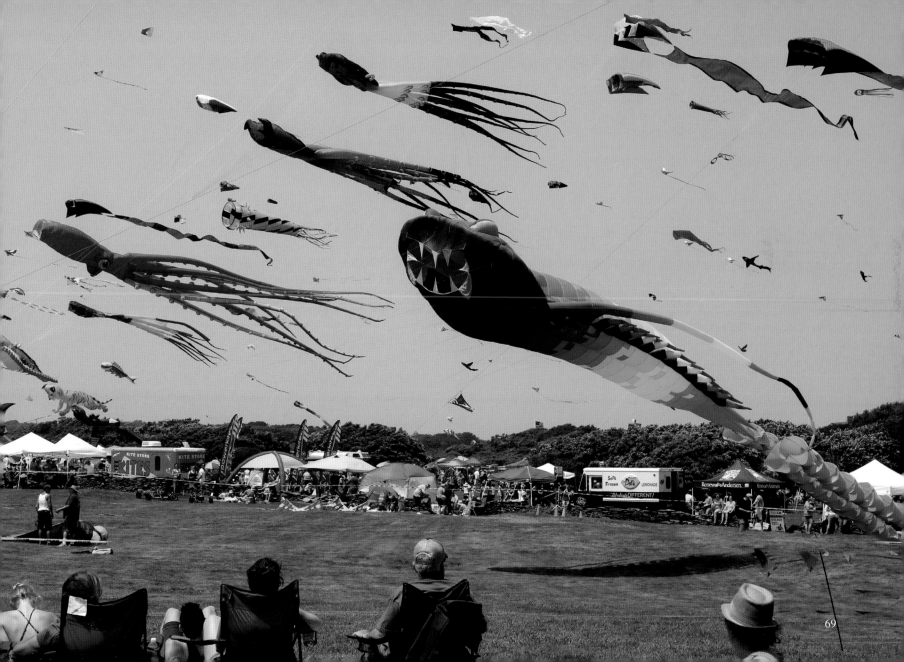

NO. 36

Sample the unique and refreshing hand-crafted beers at Grey Sail Brewing of Rhode Island

Grey Sail Brewing of Rhode Island
63 Canal Street, Westerly | www.greysailbrewing.com

Started in 2009 by local residents Alan and Jennifer Brinton, the Grey Sail Brewing Company has grown to be respected as one of the top-rated beer producers in Rhode Island. They have not only a great selection of fine hand-crafted brews, but also have a wonderful little brewing facility and tasting room on Canal Street in Westerly. It's a cozy room with lots of friendly locals and cold beer, but the hours are rather limited so you might want to check their website for tasting times before heading out. **Tip:** There are a few other local breweries nearby. Create your own little pub crawl by visiting them all!

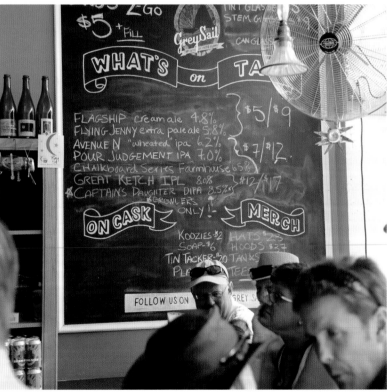

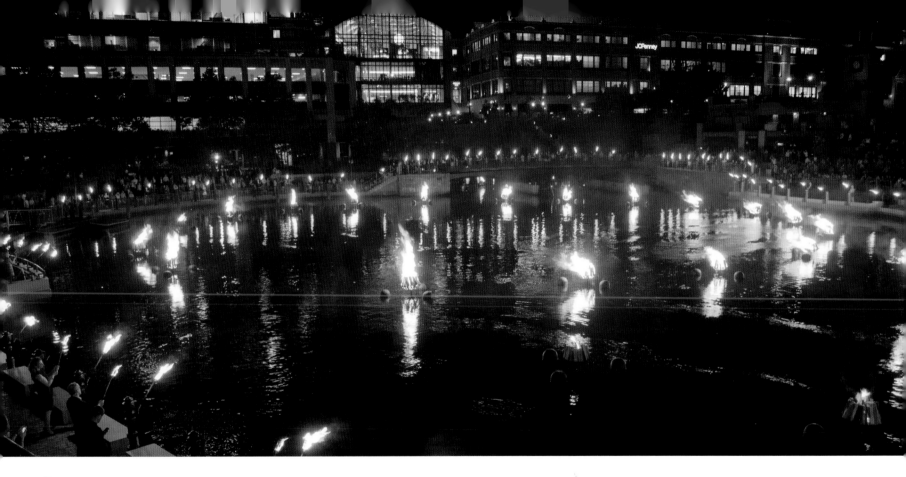

NO. 37

Revel in the glow of WaterFire, the summer spectacle that spans the three rivers in downtown Providence

WaterFire
Along the rivers of downtown Providence | www.waterfire.org

The spectacular WaterFire celebration has grown to be *the* top summer attraction in Rhode Island's capital city. Over eighty sparkling bonfires light up the downtown rivers on selected dates when hundreds of thousands of locals and tourists alike enjoy the brilliant pageantry of fire, the scent of wood smoke in the air, the flickering firelight against the arched bridges, and the sound of festive music all around. WaterFire really is the crown jewel of Providence's Renaissance.
Photo courtesy of Todd Monjar Photography

NO. 38

Cruise the three-mile stretch of classic, old-fashioned family fun along Misquamicut Beach

Misquamicut Beach
Atlantic Avenue, Westerly | www.misquamicut.org

Oh yes, this is what hanging out along the Jersey Shore in the '60s must have felt like! It's a no-frills, plastic cup, soft serve ice-cream, motorcycle cruising, cut-off blue jeans kinda wonderful place. The beach is the main attraction, but it's the carnival atmosphere along Atlantic Avenue that makes Misquamicut a real gem. Kiddie coasters, bumper cars, funky gift shops, surf shops, and bars and restaurants share the space between the street and the ocean. So put the top down on the Corvette, pop in a Beach Boys 8-track, and head to Misquamicut Beach!

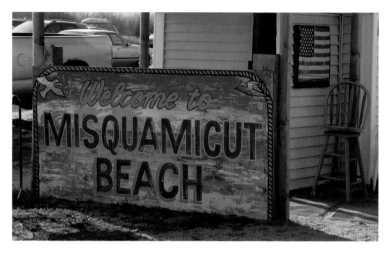

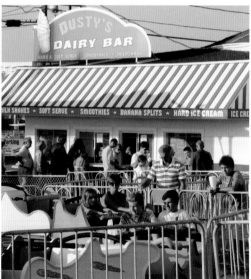

NO. 39

Take the ferry to Block Island, hop on a moped, and have a ball exploring

Block Island Ferry
Departures from Point Judith, Newport, and Fall River
www.blockislandferry.com

Unless you are fortunate enough to own a yacht or a sailboat or have the means to charter a small plane, the only way to cross the thirteen miles of ocean out to Block Island is via a ferry. There are several ferry services departing from different locations, but the most popular is the Block Island Ferry. They have traditional service (fifty-five minutes travel time) or high-speed service (thirty minutes) and they are the only line that's open year-round. **Tip:** Block Island Ferry is the only passage vessel that provides transportation for cars, and you *must* make an auto reservation in advance.

Island Moped and Bike Rentals
41 Water Street, Block Island | www.bimopeds.com

Since the sites on Block Island are fairly spread out, you are going to need a way to get around. So you might want to head on over to Island Moped and Bike Rentals. They are located just a few blocks from the ferry in the center of town. I've found that they have the best rates, and they'll provide you with instructions and very useful maps. Time to get out and explore!

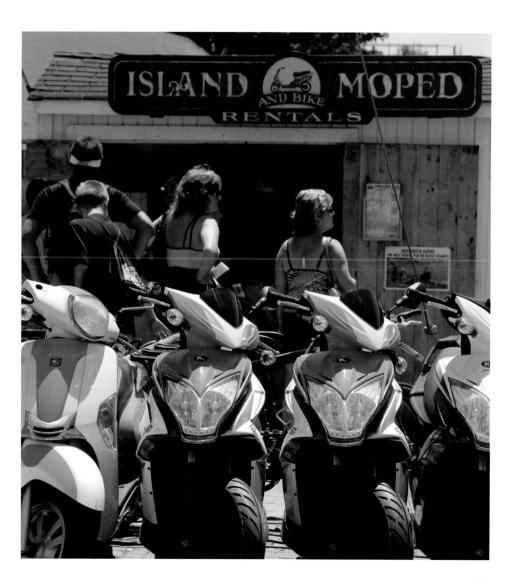

**Old Harbor shopping and entertainment
Block Island**

Much of the shopping, restaurants and entertainment on Block Island can be found near the Old Harbor, just steps away from the ferry dock in the historic downtown area. Many of the shops here are mom-and-pop businesses offering a wide range of handcrafted items. You'll find plenty of casual souvenirs, knickknacks, jewelry, clothing, fine art, pottery, and so much more. You could spend the whole day browsing, but remember, there is still lots to explore on the rest of the island!

Ballard's Beach, Harbor Pond, and Crescent Beach
Block Island

The seventeen miles of splendid beaches that encompass the island are virtually untouched. In fact, the beaches are so pristine that Block Island is often referred to as the "Bermuda of the North." The most popular of the beaches is a wonderful three-mile stretch of sand just north of the Old Harbor called Crescent Beach. That's where you can find the Frederick J. Benson Pavilion, a.k.a. Town Beach. The pavilion has a concession stand, changing rooms, and showers; you can also rent boogie boards. Paddle boarding and kayaking are popular activities on Harbor Pond, and you can find surfers enjoying the ocean waves all around the island, especially on the superior west side.

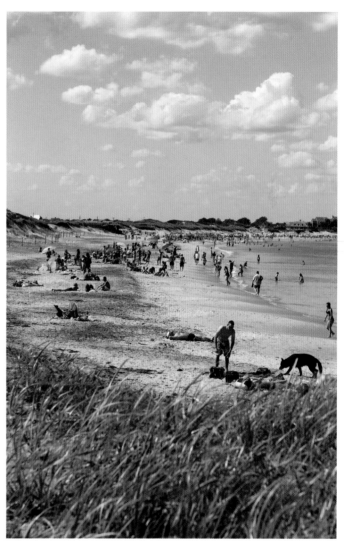

Art galleries and lobster feasts
Finn's Fish Market, 212 Water Street, Block Island
www.finnsseafood.com

Block Island has a vibrant art scene with a few resident high-profile sculptors and painters, as well as a scattering of local artists focusing on island subjects. A nice little gallery walk through the eclectic studios can be easily navigated in town. Afterward, you can stop by the Old Harbor area and pick out a freshly caught lobster for your dinner. I highly recommend Finn's Fish Market, where many of the lobsters are caught by Fred (Finn) Howarth himself. Finn's been a lobsterman setting pots around the island for over fifty years. Or you can walk down to the docks and buy a live lobster right off a boat!

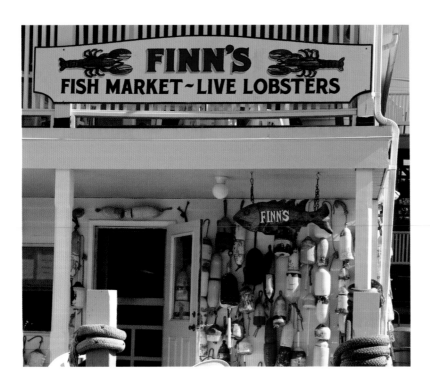

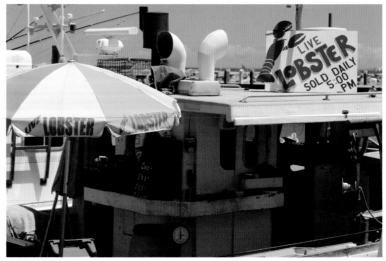

The coastline along Spring Street
Block Island

Of all the many activities on this remarkable island, one of the most enchanting just might be simply exploring the coastline, which is spectacular in any season. Follow the rolling roads, winding paths, and gently worn nature trails and you will be led to secret beaches, secluded coves, and private perches atop rocky bluffs. If you are any where on the island near the coastline, the views are just breathtaking!

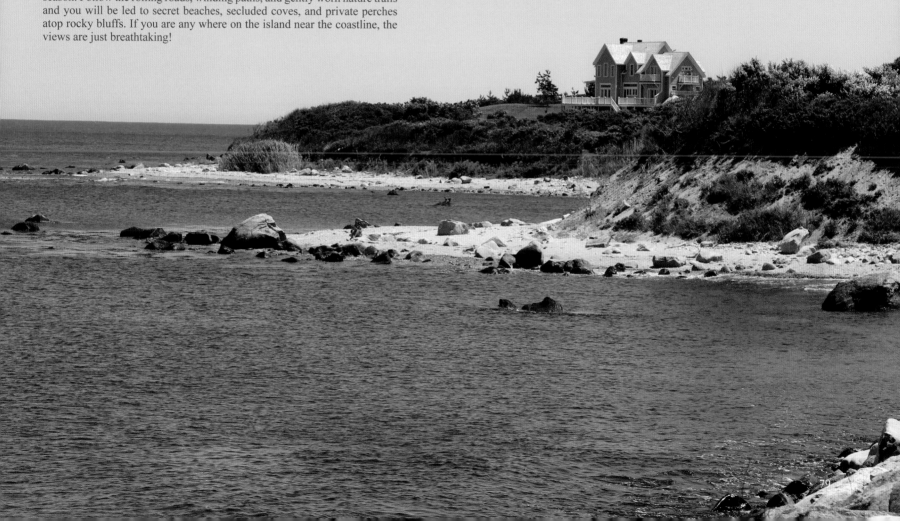

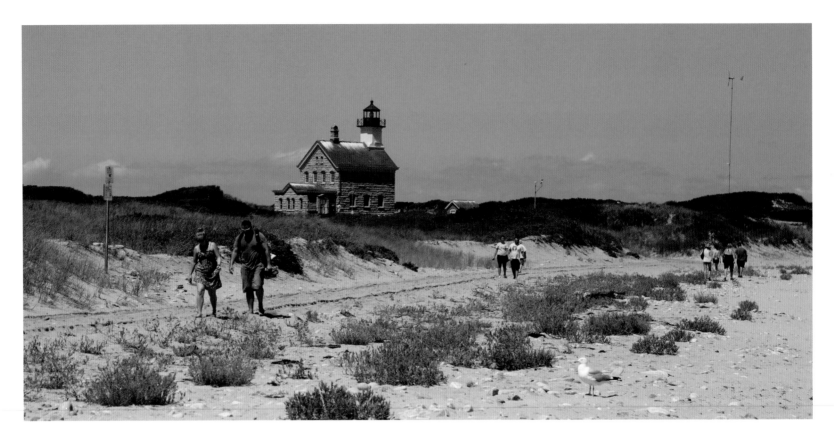

Block Island North Light
End of Corn Neck Road, Block Island | www.lighthousefriends.com

Travel all the way up Corn Neck Road and park your car or bike in the small parking lot. Unfortunately, you're not there yet— it's another half-mile walk. That doesn't sound like much, but it's in the sand! Go ahead and take off your shoes and hike through the hot, white sand along the ocean and you'll be rewarded with the picturesque Block Island North Light, built in 1867, and the adjacent Block Island National Wildlife Refuge.

Southeast Lighthouse
122 Mohegan Trail, Block Island | www.lighthousefriends.com

This iconic red-brick tower with an attached keeper's dwelling is perched atop the Mohegan Bluffs, which rise abruptly to a height of about 200 feet above sea level. The lighthouse was moved from the edge of the bluffs in 1993 as erosion threatened the structure. Be sure to climb the cast-iron spiral staircase up to the top and take in the spectacular views of the ocean.

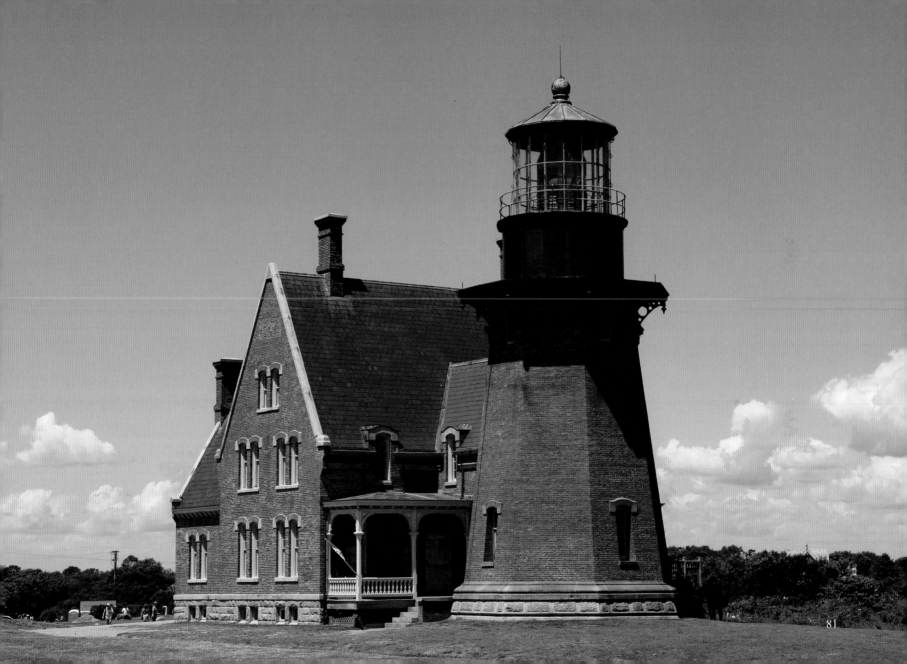

81

NO. 40

Take in a documentary or foreign film in one of Providence's independent theaters

Avon Cinema
260 Thayer Street, Providence | www.avoncinema.com

On eclectic Thayer Street near Brown University on Providence's historic East Side you will find the charming Avon Cinema. Opened in 1938, the theater specializes in foreign, independent, and documentary films. I love the art deco architecture and the heavy velvet curtains across the stage. Very old-school!

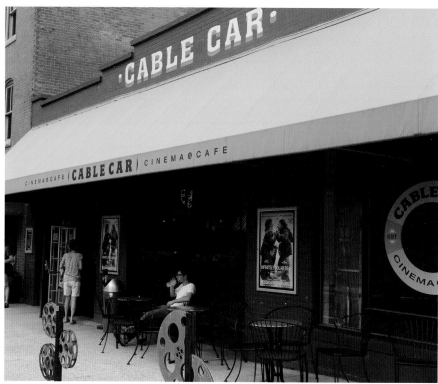

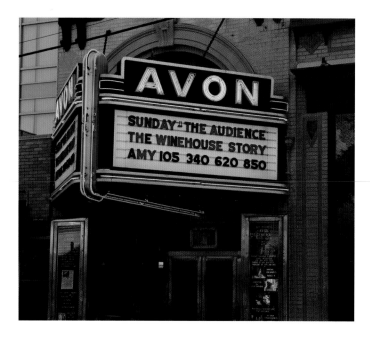

Cable Car Cinema
204 South Main Street, Providence | www.cablecarcinema.com

The intimate Cable Car Cinema on South Main really makes for a great night out. The cinema presents a wonderful rotation of foreign and independent films, and you can choose to cuddle up and watch the shows from cozy couches. They also have a nice menu of sandwiches and salads, and they serve beer and wine. Enjoy the show. The popcorn is delicious and it's all-you-can-eat!

No. 41

Sprawl out on a blanket and watch the sun set over Providence at Prospect Terrace Park

Prospect Terrace Park
Congdon Street, College Hill, Providence

The lawn might be a little small, but Prospect Terrace Park on Congdon Street at Cushing Street just might be the best spot in the state's capital city to have a nice little sunset picnic. Perched high above the city in College Hill, this neighborhood park has wonderful panoramic skyline views overlooking the State Capitol and the Downcity neighborhood. Join Roger Williams, the state's founding father, as he peacefully watches the sun set over Providence.

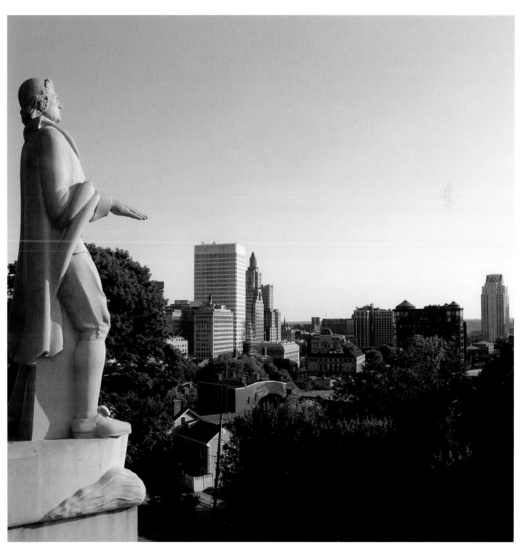

NO. 42

Enjoy the classic beef
Wellington at America's
oldest tavern, the White Horse
Tavern, opened in 1673

White Horse Tavern
26 Marlborough Street, Newport
www.whitehorsenewport.com

If you would like a slice of history served up with
your meal, look no further than the historic White
Horse Tavern in Newport—the oldest operating
tavern in America. This charming colonial tavern
was established in 1673, where it once was a
gathering place for colonists, British soldiers,
pirates, sailors, and some of America's founding
fathers. They have a wonderful contemporary
menu with lots of seafood and other great choices,
but it's their classic beef Wellington that comes
most highly recommended.

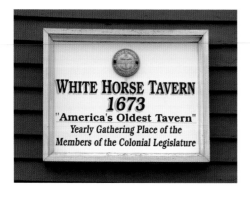

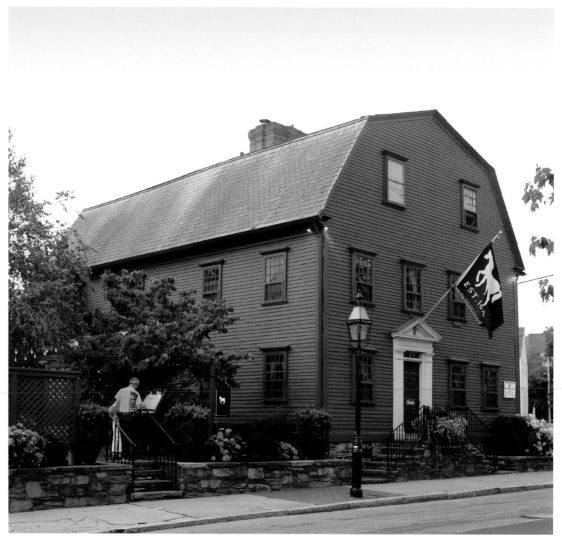

NO. 43

Ramble along at Sunset Stables on a guided horseback ride through the scenic trails of Lincoln Woods

Sunset Stables
1 Twin River Road, Lincoln | **www.sunsetstablesri.com**

If you are looking for a fun way to get out and enjoy the great outdoors, you've got to grab the reins and try a guided horseback ride. No experience needed. If you've never ridden a horse, Sunset Stables will provide instruction and then take you for a walking-pace ride through the forest trails of the sprawling, wooded landscape of Lincoln Woods State Park. They even have ponies for the kids! And they are open year-round, so you can enjoy a ride in any season.

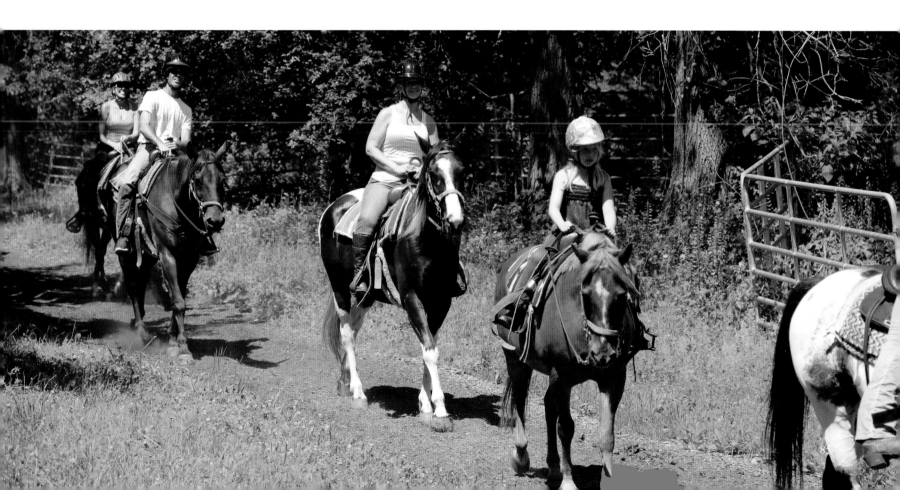

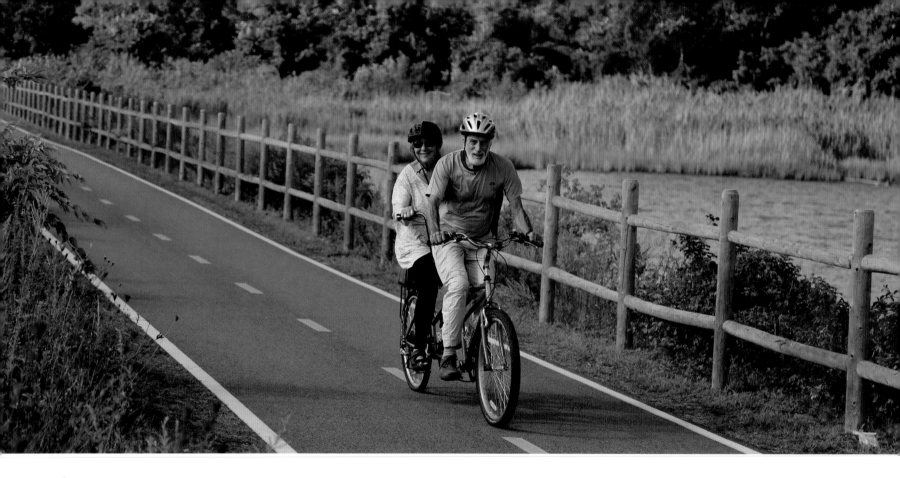

NO. 44

Jump on a bicycle-built-for-two and peddle away on the popular East Bay Bike Path

East Bay Bike Path
From India Point Park in Providence to Bristol | www.riparks.com

Rhode Island's best-known and most popular trail is the fourteen-mile ribbon of asphalt called the East Bay Bike Path. This ultra-scenic trail stretches from India Point Park in Providence in the north out to the charming town of Bristol in the south. It travels along the shores of Narragansett Bay, passes by coves and marshes, glides over bridges, weaves in and out of local neighborhoods, and crosses through state parks. The well-maintained path will not only provide exercise, relaxation, and spectacular scenery, it's sure to revive your soul!

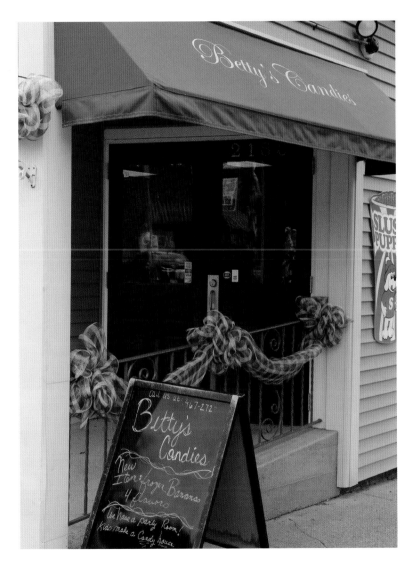

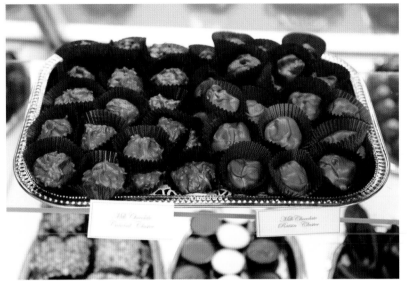

NO. 45

Savor Rhode Island's best homemade chocolate nut clusters at Betty's Candies in Cranston

Betty's Candies
2180 Broad Street, Cranston | www.bettyscandy.com

You would be nuts not to try Betty's Candies! Homemade fudge, penny treats, delectable chocolates, and gourmet Granny Smith apples; all of this and more is waiting for you at Betty's in the heart of historic Pawtuxet Village. But what you really should try are those award-winning chocolate nut clusters. You'd think that they might be the store's top seller, but they're not: that distinction goes to their handmade chocolate covered bacon! Yummy!

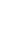

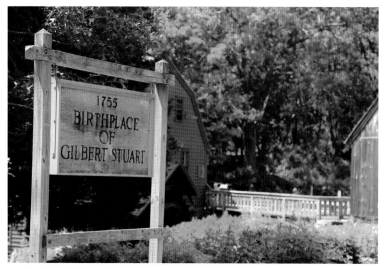

NO. 46

Visit eighteenth-century master portrait artist Gilbert Stuart's birthplace and museum

Gilbert Stuart Birthplace and Museum
815 Gilbert Stuart Road, Saunderstown
www.gilbertstuartmuseum.org

Gilbert Stuart, a famous American portraitist of the eighteenth and nineteenth centuries, was born right here in a snuff mill in Saunderstown, Rhode Island. He grew up to be the portrait painter of America's first six presidents. His most famous portrait is one he created of George Washington, which ended up on the one-dollar bill. The authentically restored 1750 gambrel-roofed workingman's home, delightfully furnished with period antiques, is now an excellent showplace for reproductions of Stuart's historic work.

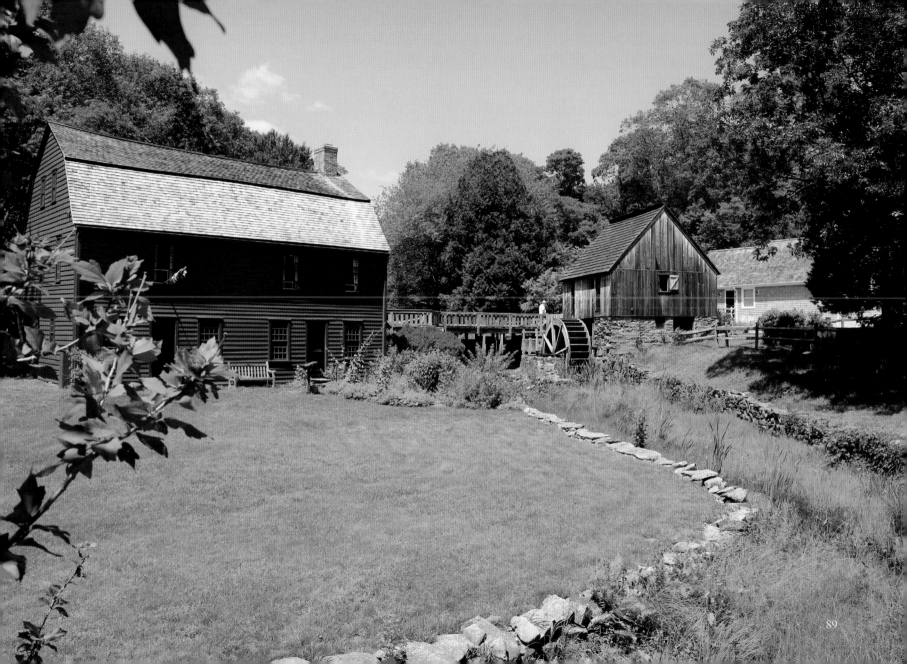

NO. 47

Climb to the bonnet of an actual windmill in the historic Windmill Hill District in Jamestown

Jamestown Windmill
North Road near Weeden Lane, Jamestown
www.jamestownhistoricalsociety.org

High atop Windmill Hill in the center of Conanicut Island stands the Jamestown Windmill—a delightful smock mill that is part of the Windmill Hill Historical District. Built in 1787, it replaced a windmill that was destroyed during the Revolutionary War. The three-story structure remained in productive operation until 1896. Although admission is free to this functional windmill, the hours are very short and limited to weekends. But it does make for a nice, quick stop on the way to Jamestown.

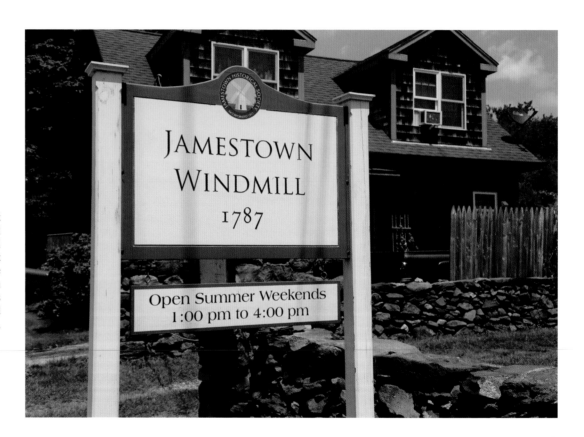

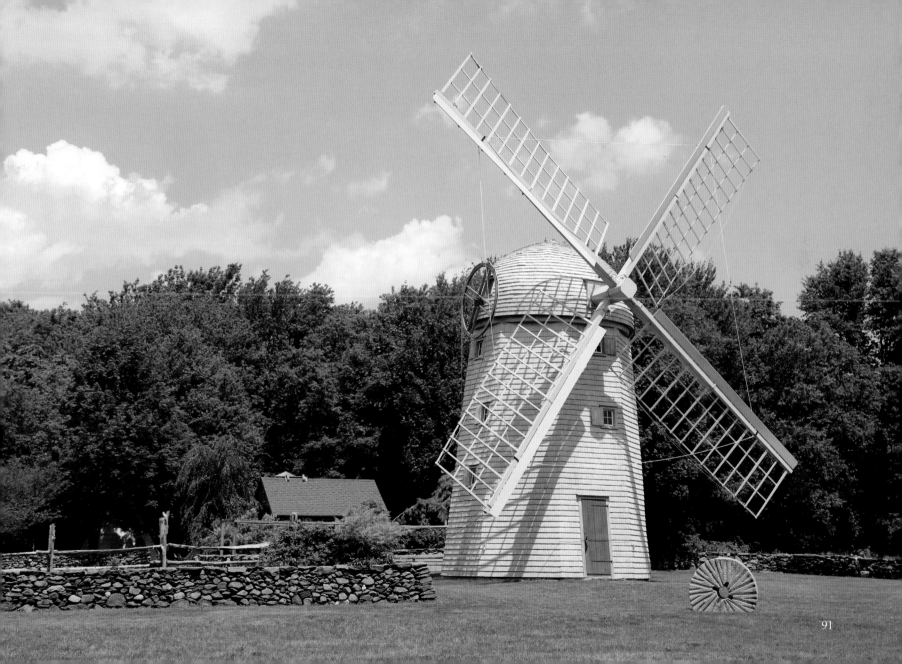

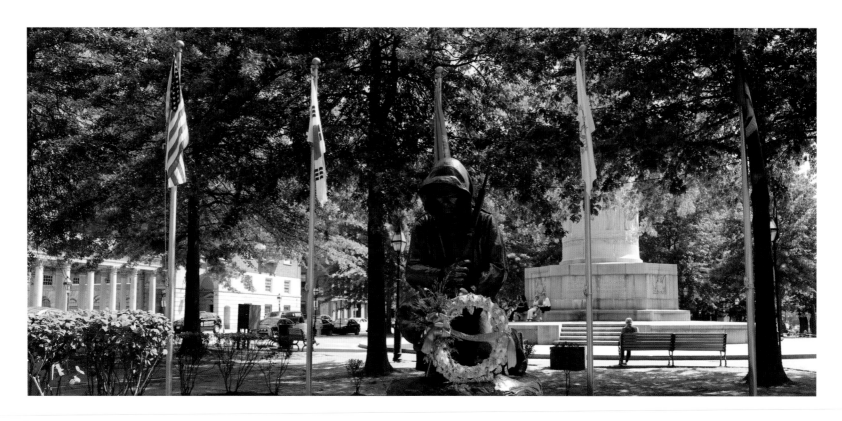

NO. 48

Salute our veterans at the impressive World War II Memorial Park right on the Providence River

World War II Memorial Park
South Water Street, Providence

Hopefully, when you are in Providence you will have time to visit Memorial Park to pay your respects to the men and women from Rhode Island who lost their lives defending our country. This beautiful park is situated right along the river and features a marvelous circular World War II Memorial, along with a 150-foot-high granite column dedicated to World War I, and, in remembrance of those who died in the Korean War, a solemn bronze sculpture of a soldier holding his rifle as he kneels. It really is a moving tribute to those who served, as well as a lovely park. The site makes for a nice evening stroll and is an excellent spot to watch WaterFire events.

NO. 49

Feed the giraffes and watch the elephants frolic in the dirt at Roger Williams Park Zoo

Roger Williams Park Zoo
1000 Elmwood Avenue, Providence | www.rwpzoo.org

This is one really cool zoo! Not too big, not too small, it's just the right size. It opened in 1872, making Roger Williams Park Zoo one of the oldest zoos in the country. The easy-to-follow circular trails lead to over one-hundred species of rare, endangered, and otherwise-fascinating animals from around the globe. There are lots of wonderful close-up opportunities; you can feed the goats and giraffes, ride a camel, or have an exotic butterfly land on your shoulder.

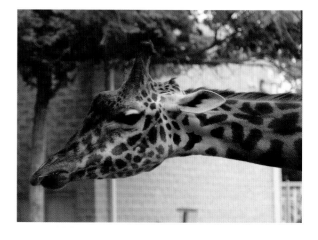

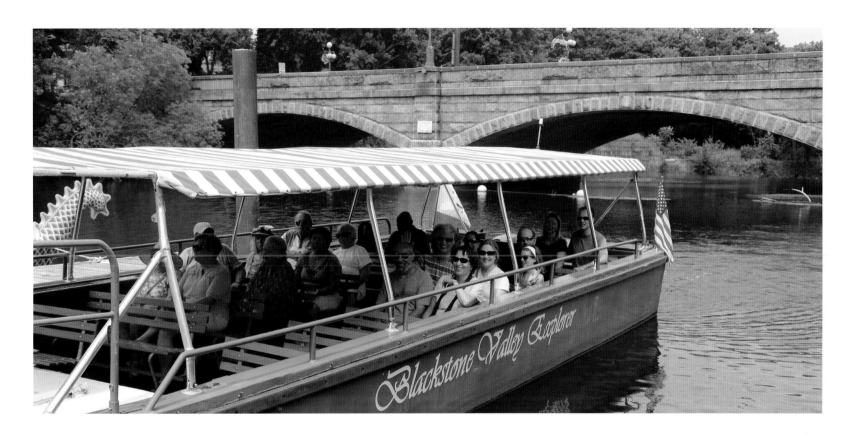

NO. 50

See the beauty and hear the stories of the rich history of Blackstone Valley on a river cruise

Blackstone Valley Explorer
Central Falls Landing, 45 Madeira Avenue, Central Falls | www.rivertourblackstone.com

The Blackstone River Valley runs from Worcester, Massachusetts, to Providence, Rhode Island, and all along the way its mighty waters helped to power factories in the American Industrial Revolution. You can learn all about that rich history by taking a riverboat cruise with the Blackstone Valley Explorer. You'll get to experience the mill towns and the living landscape along the river, and also have fun checking out the turtles, hawks, herons, ducks, and swans that frolic in the water.

NO. 51

Take a whirl up Bellevue Avenue in Newport and marvel at all the magnificent mansions

Chateau-sur-Mer
474 Bellevue Avenue, Newport
www.newportmansions.org

The stunning Chateau-sur-Mer, completed in 1852, is considered one of America's finest examples of lavish Victorian architecture. It was built for the China trade merchant William S. Wetmore, and its grand size and extravagant parties ushered in the Gilded Age of Newport. The interior features beautiful wooden floors, hand-carved Italian woodwork, Chinese porcelains, Japanese Revival stenciled wallpapers, and priceless period furnishings.

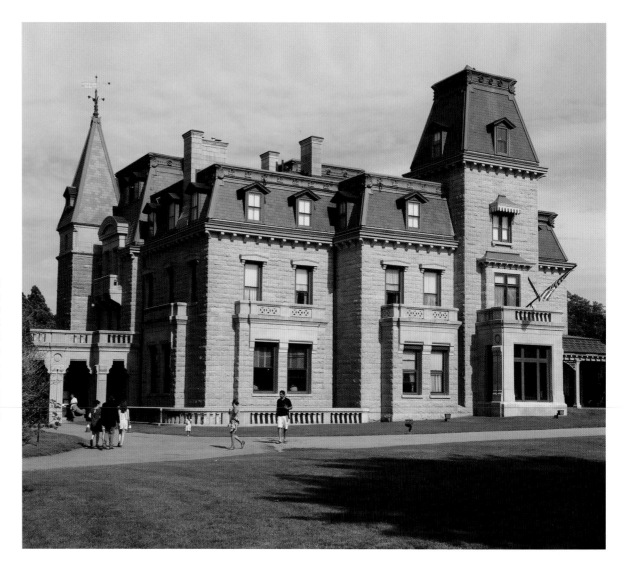

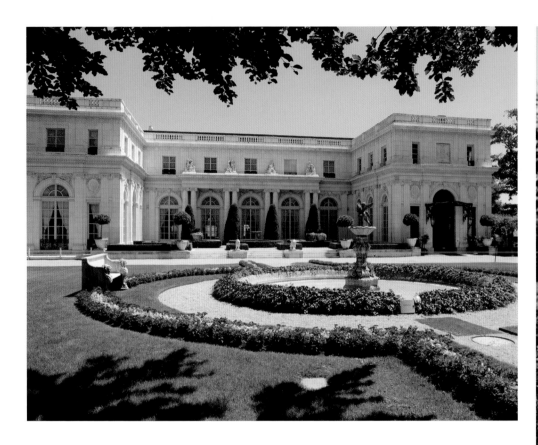

Rosecliff
548 Bellevue Avenue, Newport | www.newportmansions.org

Modeled after the Grand Trianon, the garden retreat of French kings at Versailles, Rosecliff has been inhabited by a series of colorful families. It was completed in 1902 at a reported cost of $2.5 million, and has been used as a shooting location for several films, including *The Great Gatsby, True Lies*, and *27 Dresses*. As they are for most of the grand mansions on Bellevue Avenue, daily tours are offered by The Preservation Society of Newport County.

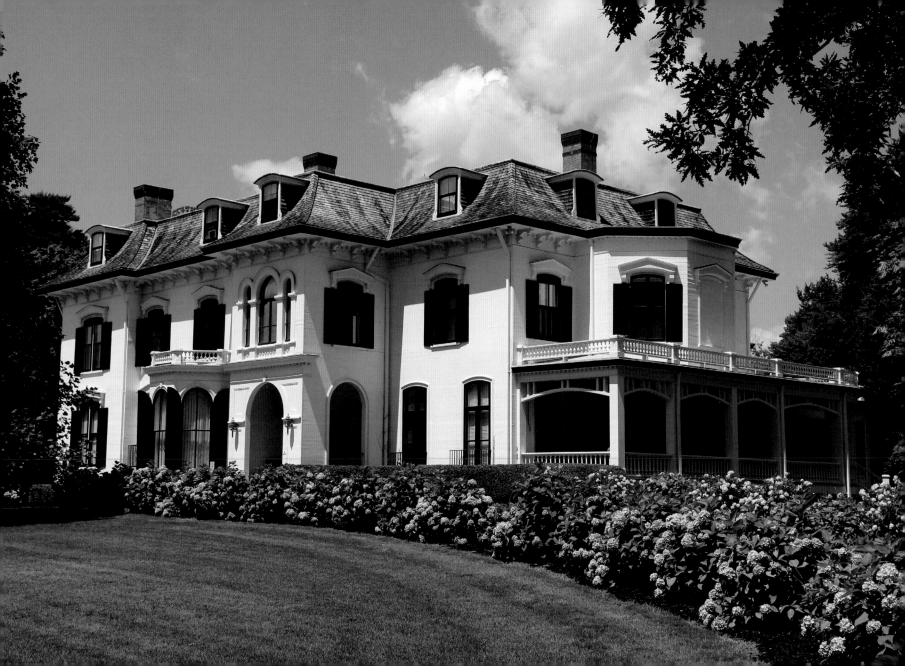

Chepstow
120 Narragansett Avenue, Newport
www.newportmansions.org

Chepstow is a charming Italianate-style villa just off Bellevue Avenue. It was built in 1860 and acquired by Mrs. Emily Morris Gallatin in 1911. The mansion still contains original family furnishings together with a collection of important nineteenth-century American paintings. Chepstow was bequeathed to the Preservation Society in 1986.

De La Salle
364 Bellevue Avenue, Newport

Built in 1884, the De La Salle estate is one of the few magnificent mansions on Bellevue Avenue that is not open to the public. Between the years 1924 and 1972 it served as part of the De La Salle Academy, a private boys' high school. When the academy closed its doors in 1972, the building was converted to private luxury condominiums.

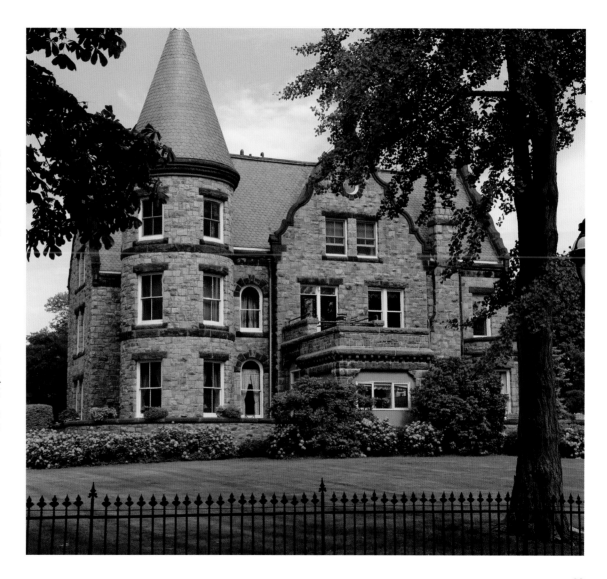

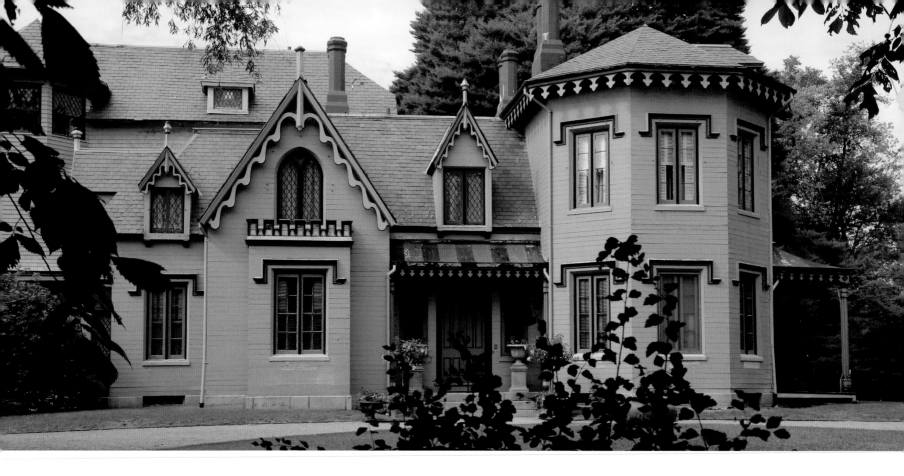

Kingscote
253 Bellevue Avenue, Newport | www.newportmansions.org

Kingscote is a wonderful, rare example of American Gothic revival architecture. The interior possesses rooms originally decorated from the 1840s and the 1880s. The mansion is noted for having one of America's greatest dining areas, as well as rooms with rare furniture, Chinese decorative arts, unique cork ceiling tiles, and opalescent glass bricks designed by Tiffany.

Marble House
596 Bellevue Avenue, Newport | www.newportmansions.org

The fifty-five-room Marble House was built between 1888 and 1892 for Alva and William Vanderbilt. Containing 500,000 cubic feet of marble, it was a social landmark that helped spark the transformation of Newport from a relatively relaxed summer colony of wooden houses to the legendary resort of opulent stone palaces. **Tip:** Make sure to have a look out back where a lavish Chinese Tea House was built on the seaside cliff overlooking the Atlantic Ocean.

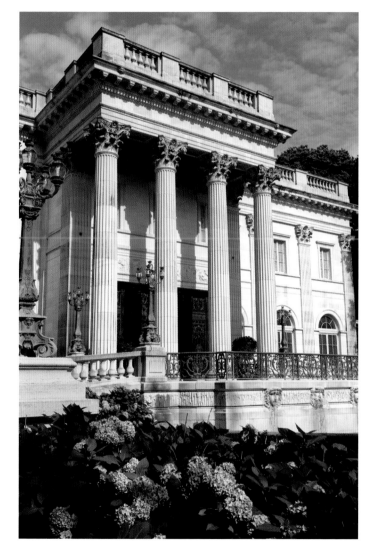

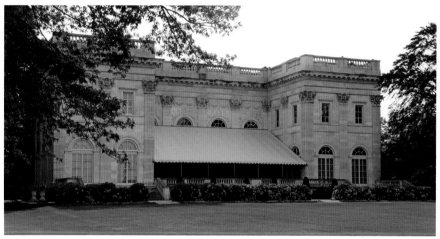

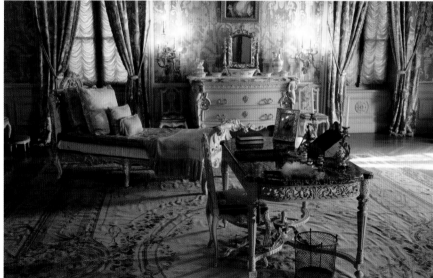

NO. 52

Spend a secluded, romantic evening in the rustic Rose Island Lighthouse on tiny Rose Island

Rose Island Lighthouse
Narragansett Bay, between Jamestown and Newport
www.roseislandlighthouse.org

What a great chance to be a lighthouse keeper! This charming lighthouse was restored in 1993 and is open for tours on a daily basis. But after 4:00 p.m. the ferry out of nearby Newport Harbor stops running, and the Rose Island Lighthouse, the second-floor keeper's quarters, and the entire little island could all be yours! Rent it for a night or a week-long vacation. Your only neighbors will be the gulls, as most of the tiny island is a wildlife refuge.

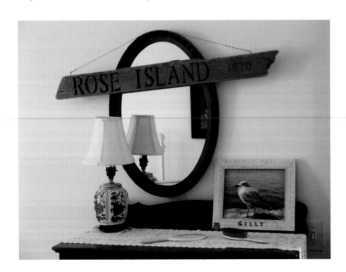

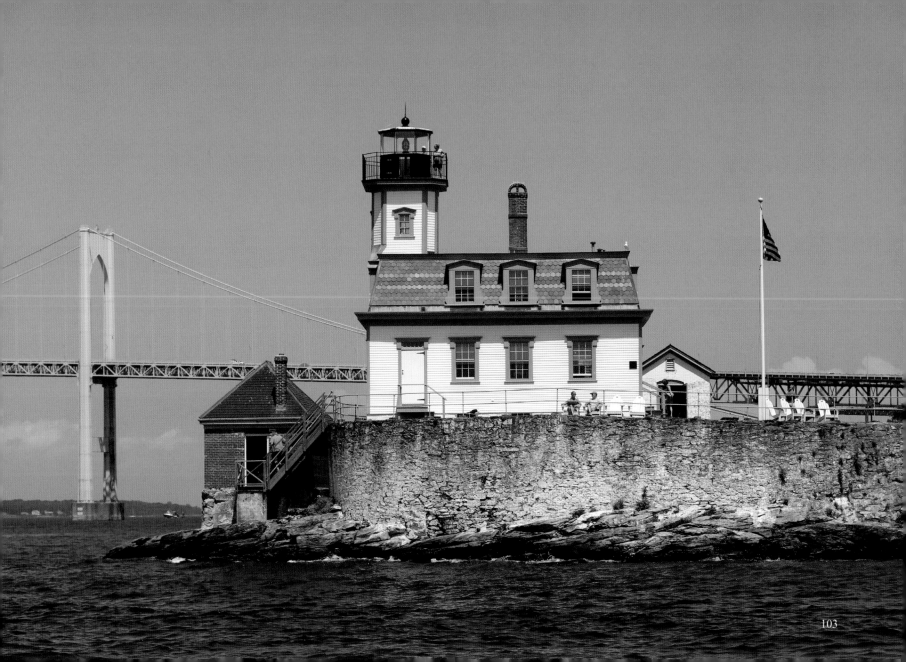

NO. 53

Do a little shopping along the harbor in historic Wickford Village

Wickford Village
Main Street at Brown Street, Wickford Village, North Kingston
www.wickfordvillage.org

The quaint village of Wickford is on the west side of Narragansett Bay just across the two bridges from Newport. It was first settled around 1637, and its picturesque waterfront streets are lined with small shops, galleries, cafes, and restaurants—as well as colonial homes, solemn churches, and beautiful gardens. Bring along your dog, who will enjoy a refreshing drink of water outside many of the shops, as Wickford Village is very pet-friendly.

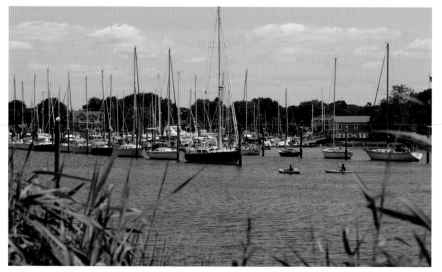

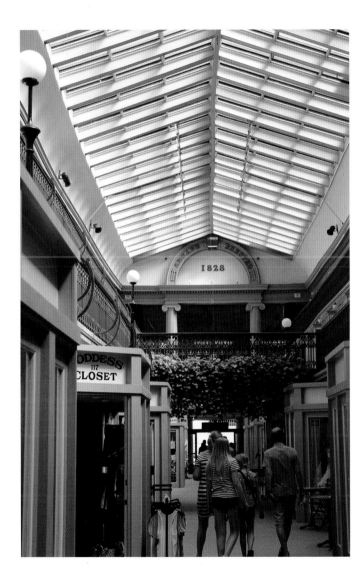

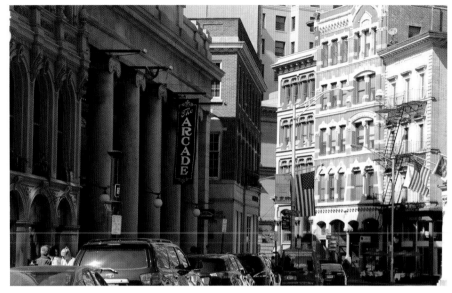

NO. 54
Check out the sleek new look of Arcade Providence, the nation's oldest indoor shopping mall

Arcade Providence
65 Weybosset Street, Providence | www.arcadeprovidence.com

Those who enjoy local shopping, beautiful architecture, and successful renovations are really going to smile when entering the arcade in downtown Providence. The two-story arcade, with its arched glass atrium ceiling and decorative ironwork, stretches between Westminster and Weybosset Streets. It was built in 1828, making it the oldest indoor shopping mall in America. The new look has attracted boutiques featuring creative clothing, artwork, and vintage items, as well as a salon, a coffee shop, and a local restaurant with an inviting bar. It's well worth a visit!

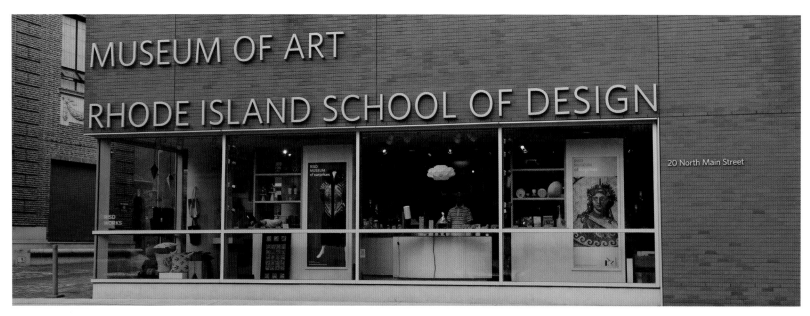

NO. 55

Marvel at the endless art masterpieces at the internationally renowned RISD Museum

Rhode Island School of Design Museum
20 North Main Street, Providence | www.risdmuseum.org

From the outside, it might appear that the RISD Museum is a small studio dedicated to works by the student body. Wow! How appearances can be deceiving! Not only is the institution much bigger than it appears, but it is a remarkable museum filled with everything from ancient art to works by popular contemporary artists and designers from around the globe. Paintings, costumes, textiles, Egyptian art, prints, drawings—it is truly an extraordinary collection. **Tip:** The admission is free on Sundays and on the third Thursday evening of every month.

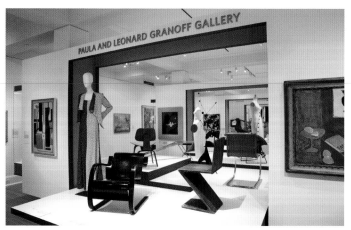

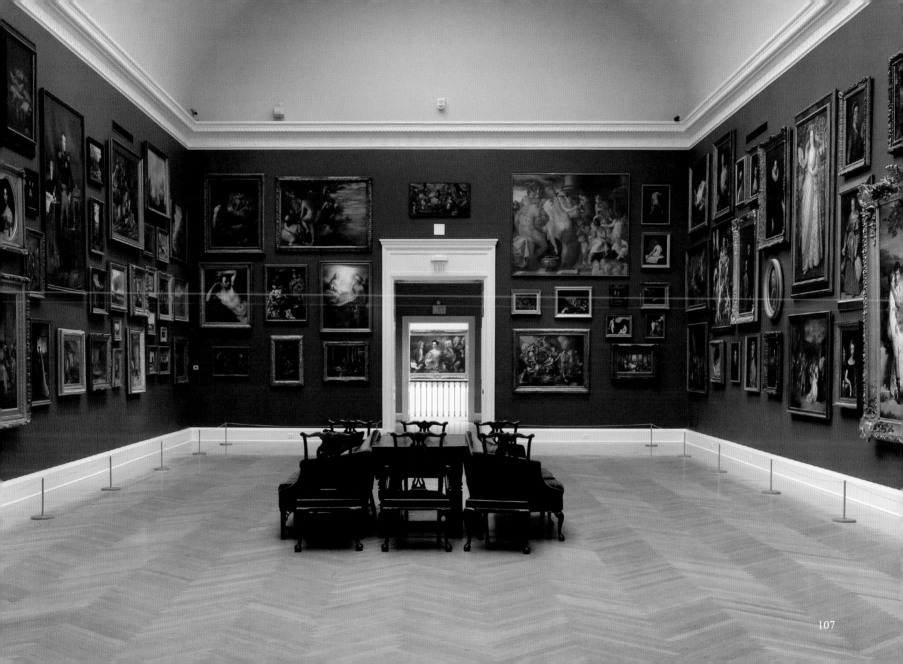

NO. 56

Savor a bowl of the Black Pearl's world-famous clam chowder on Newport's waterfront

The Black Pearl Restaurant
Bannister's Wharf, Newport | www.blackpearlnewport.com

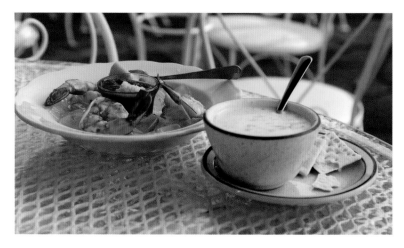

New Englanders love their clam "chowda," and the best-of-the-best can be found at the Black Pearl on Bannister's Wharf in the heart of Newport's bustling waterfront. Their chowder has a creamy, deep flavor, and it is chock full of clams. It's won many, many awards and can be enjoyed inside the tavern or al fresco on the cozy waterfront patio. Grab a cup or a bowl and watch the world sail by!

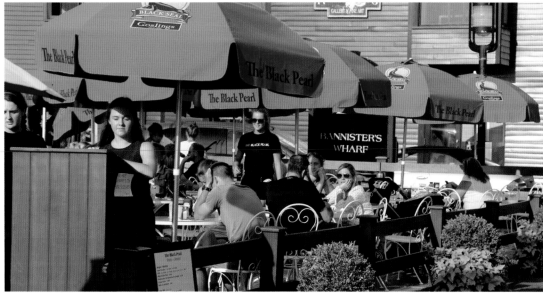

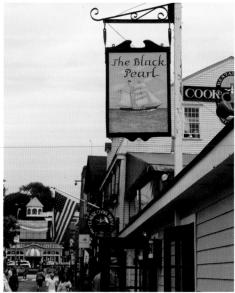

NO. 57

Take the famous ten-mile oceanfront ride along scenic Ocean Drive, lined with parks, beaches, and lots of mansions

Newport's famous Ten-Mile Drive
Ocean Drive, Newport | www.oceandrivenewport.com

Ranked as one of the most popular "drives" in the country, the ten-mile trip on Newport's famed Ocean Drive combines magnificent mansions, public parks, really cool rock formations, and spectacular views of the Atlantic Ocean. Be sure to stop at Brenton Point State Park, which is about midway through the drive. The park is at the southern-most point of Aquidneck Island and offers plenty of free parking, comfortable wooden benches spread out along the waterfront, and majestic vistas of the Atlantic. **Tip:** The Ocean Drive excursion makes for nice ride after visiting the nearby mansions on historic Bellevue Avenue.

NO. 58

Rent your own kayak, or join a kayak tour, and paddle your way out to the ocean

Narrow River Kayaks
94 Middlebridge Road, Narragansett | www.narrowriverkayaks.com

One of the popular pastimes in Rhode Island is jumping in a canoe or kayak or on a paddleboard and enjoying the day on the water. You can rent your equipment at Narrow River Kayaks in Narragansett. The location is just a short distance from Narrow River, Pettaquamscutt Cove, John Chafee Wildlife Refuge, and the Atlantic Ocean. And if you're a novice and stick to the river, the average depth is only a friendly one-to-four feet.

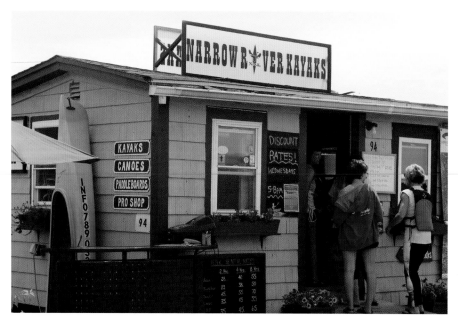

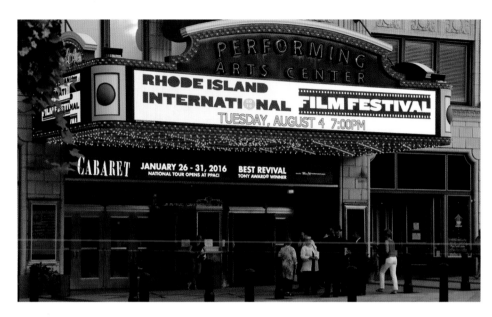

NO. 59

Experience touring Broadway shows at the world-class Providence Performing Arts Center

Providence Performing Arts Center
220 Weybosset Street, Providence | www.ppacri.org

Providence Performing Arts Center, or PPAC as it is known around town, is the city's magnificent venue for touring Broadway shows, concerts, plays, and other major performances. The 3,100-seat theater opened in 1928 and has been recently restored to its original opulence. It now shines with golden trim, beautiful tapestries, sensational ceiling art, and sparkling chandeliers. **Tip:** PPAC offers occasional free concerts performed by local organists on its historic 1927 mighty Wurlitzer pipe organ. Check their website for details.

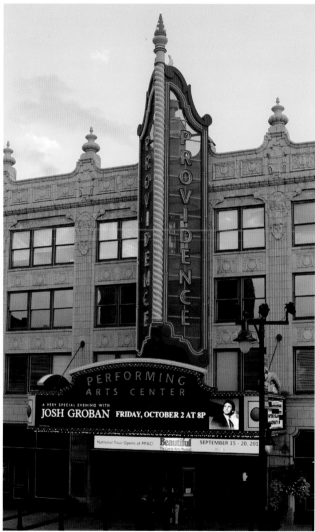

NO. 60

Enjoy the awe-inspiring views
and trendy cocktails at the upscale
Rooftop at the ProvidenceG

Rooftop at the ProvidenceG
100 Dorrance Street, Providence | www.providenceg.com

Grab a bite to eat or a cool beverage at the loftiest bar in the city, the Rooftop at the ProvidenceG. If you're hungry you can choose from a selection of small plates or from the raw bar. If not, just simply hang out with a fancy cocktail or seasonal beer and mingle with Providence's well-dressed movers and shakers. The bar is perched seven stories above downtown, so there are pretty good views in every direction. **Tip:** You must enter from the front entrance off Dorrance Street and take the elevator up to the rooftop.

NO. 61

Stroll down eclectic Thayer Street in College Hill and look into all the neat shops and restaurants

Strolling along Thayer Street
Between Waterman & Bowen Streets, Providence | www.thayerstreetdistrict.com

In the College Hill area on Providence's East Side and surrounded by internationally renowned educational institutions like Brown University and the Rhode Island School of Design, Thayer Street is definitely the popular and hip destination of the college crowd looking to shop, eat, drink, and relax. The eclectic six-block avenue is a wonderful mix of sophisticated apartments atop clothing shops, sporting good stores, hair salons, gift shops, the historic Avon Theater, Brown University Bookstore, and lots and lots of restaurants! It's a great place to stroll and people watch.

NO. 62

If you're a fan of Downton Abbey, don't miss the behind-the-scenes Servant Life Tour at The Elms

Servant Life Tour at The Elms
367 Bellevue Avenue, Newport | www.newportmansions.org

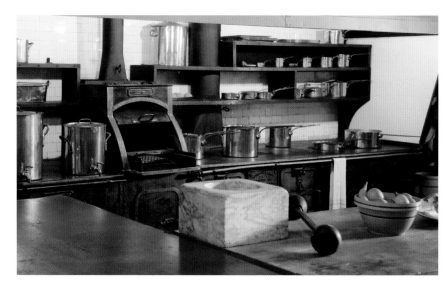

If you're a fan of *Downton Abbey* and really want to get a unique insider's peak of the lives of ordinary people who worked behind the scenes in these great mansions on Bellevue Avenue, you must sign up for the Servant Life Tour at the Elms. This wonderful tour will take you up the eighty-two steps of the back staircase to the third floor living quarters, where the guide will reveal some very interesting stories of the butler, cook, maids, and other staff members. There are also visits to the kitchen, boiler room, laundry room, and other private behind-the-scene areas. Extremely informative!

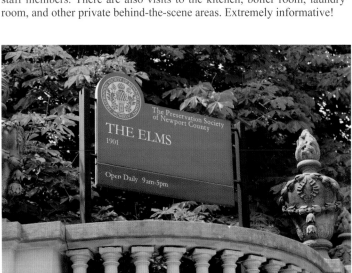

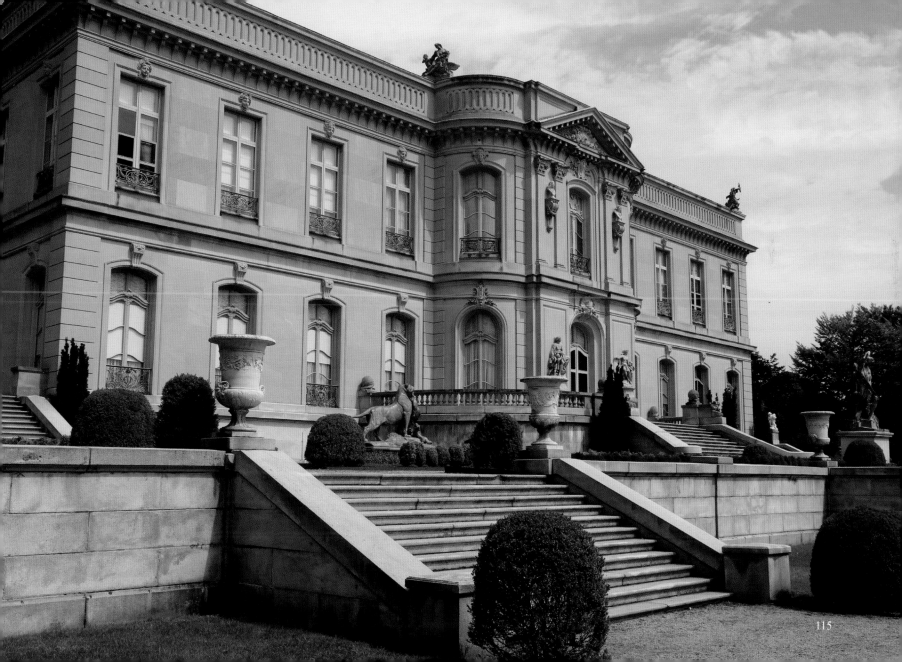

NO. 63
Spend the night singing and cocktailing at The Dean, the ultra-hip boutique hotel in Providence

The Dean
122 Fountain Street, Providence | https://thedeanhotel.com

A chic new addition to the downtown lodging scene in Providence is the Brooklyn-esque Dean Hotel. Yes, it's a cool place to stay, but it's the Dean's nightlife that makes this place worth a visit. Faust is their German-style beer hall, the Magdalenae Room is a dimly lit place for professionally mixed cocktails, and the Boombox is Providence's first and only karaoke lounge. There's also a really neat upscale coffee shop with an adjoining lounge filled with books and magazines. What a great hotel right in the heart of Providence!

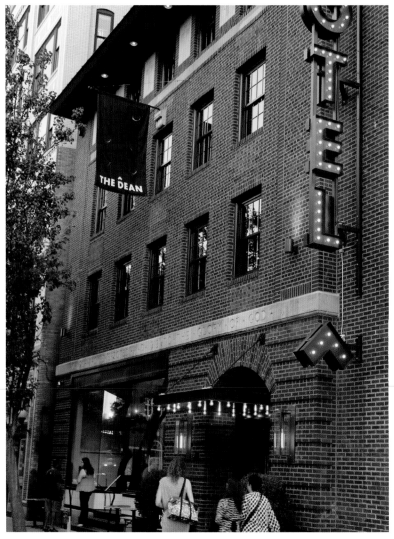

The Boombox
www.singboombox.com

Providence's first and only karaoke lounge is the Boombox in the rear of the Dean Hotel. Grab a sake and belt out a tune in the Tokyo-inspired main room, or rent a private karaoke room for your group. It's a really fun and unique space!

The Magdalenae Room

The Magdalenae Room is an intimate, dimly lit, discreet cocktail lounge reminiscent of the fine hotel bars of Europe. There's a superb cocktail list, and it's a great place to cuddle up with a lover, or to meet someone new!

Faust
www.faustpvd.com

Faust is a hip restaurant and beer hall in the grand German tradition. Their menu includes a robust selection of sausages with an admirable Bavarian draft beer list. Drop in and hang out at the bar or at one of the long Hofbrauhaus-style tables.

NO. 64

Look over the history of yachting's most distinguished competition at the America's Cup Hall of Fame

**Herreshoff Marine Museum/
America's Cup Hall of Fame
1 Burnside Street, Bristol
www.herreshoff.org**

The America's Cup Hall of Fame, an arm of the Herreshoff Marine Museum in Bristol, showcases racing memorabilia and honors individuals who have made outstanding contributions to yachting's most distinguished competition. Bordering beautiful Narragansett Bay, the hall was founded by Halsey Herreshoff, four-time America's cup defender and grandson of legendary yacht designer Nathanael Herreshoff. Be sure to stop into the adjoining marine museum, which houses more than sixty perfectly restored yachts, steam engines, boats, and other fascinating sailing vessels.

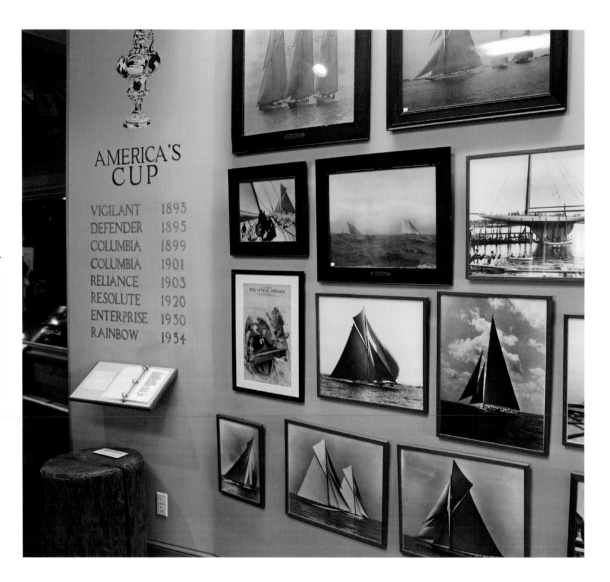

NO. 65

Say a prayer at lovely St. Mary's Church, where a guy named John married a gal named Jacqueline

St. Mary's Church
12 William Street, Newport
www.stmarynewport.org

Yes, you can return to Camelot! Historic St. Mary's Roman Catholic Church in Newport is where John F. Kennedy married Jacqueline Lee Bouvier on September 12, 1953. And, on selected dates, St. Mary's immortalizes the occasion with a presentation entitled *Return to Camelot – The Kennedy Wedding*. The church is at Spring Street and Memorial Boulevard, and is usually open for visitors on weekdays from 8:00 a.m. to 11:30 a.m. Check their website for details.

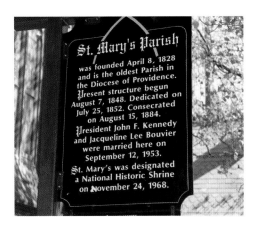

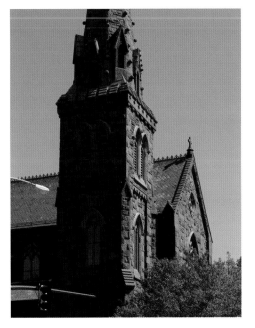

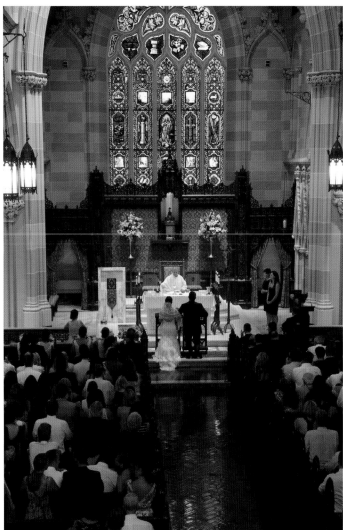

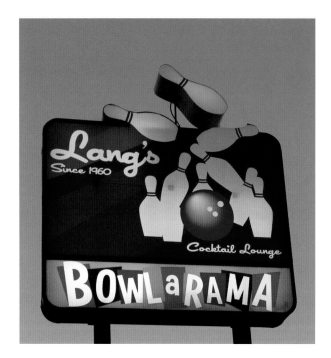

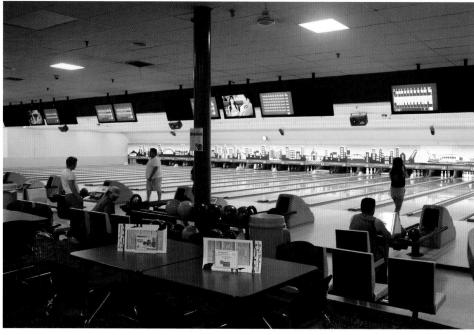

NO. 66

Strike up an evening of retro entertainment at Lang's Bowlarama

Lang's Bowlarama
225 Niantic Avenue, Cranston | www.langsbowlarama.com

Founded by Ed Lang in 1960 and now run by his grandchildren, this celebrated Cranston icon has been lovingly restored to its glory days of the 1960s. The place is bright and colorful with really cool retro decor and kaleidoscopic bowling balls. A fun time to visit would be on Thursday through Sunday nights, when live DJs and lasers light up the lanes.

NO. 67

Soak up four centuries of the city's history with a walk along the Providence Heritage Trail

Rhode Island State Capitol
82 Smith Street, Providence

The State Capitol building is one of the many sites you will see along the Providence Heritage Trail, a 2.5-mile circular loop around the downtown area. Just follow the green stripe. Along the route you will find emblems with phone numbers. Call the number, and you will be connected to a recorded narrative telling you about the interesting sites you can see from that spot.

First Baptist Church of Providence
75 North Main Street, Providence

Another significant site along the green-striped trail is the oldest Baptist church in the United States. Founded by Roger Williams in 1638, the building that stands here now was erected in 1775. The church is flawlessly preserved and features a magnificent Waterford crystal chandelier dating from 1792.

NO. 68

Rent a sailboat or take some lessons at Sail Newport, Rhode Island's largest public sailing center

Sail Newport's Youth Sailing Program
60 Fort Adams Drive, Newport | www.sailnewport.org

If you've been admiring all the sailboats on Narragansett Bay and dreaming about being out on the water yourself, here's your chance. Sail Newport is Rhode Island's premier public sailing site. They offer award-winning sailing instructional program for adults, a youth sailing program for the kids, and fleets of rental sailboats. Their large sailing center is inside picturesque Fort Adams State Park.

NO. 69

Interact with one of Rhode Island's many creative local artists at a POP-Up or a Meet & Greet

Vincent Castaldi's POP-Up Art Show @ Ello Pretty
52 Valley Street, Providence | www.vincentcastaldiart.com , www.ellopretty.com

Rhode Island—and Providence in particular— has a refreshingly vibrant, creative, growing, local art community. And one of the best ways to experience the excitement of that art scene is to join-in and attend a neighborhood Gallery Night, Meet & Greet, or a POP-Up event. It's a great opportunity not only to see new works, but also to learn about the artists and their creative process. One such well-respected local artist is Vinny Castaldi, shown here introducing his recent project *Reclaimed*.

NO. 70

Return to the golden days of rail travel and enjoy an elegant dining experience while traveling along Narragansett Bay

Newport and Narragansett Bay Railroad Company
22 America's Cup Avenue, Newport | www.trainsri.com

For a really unique adventure that combines food with sightseeing, take a ride with Newport & Narragansett Bay Railroad. You can dine in the tradition of the "Streamliner" era aboard the Grand Bellevue, an elegant 1950s rail dining car. They offer a ninety-minute lunch trip or a two and a half–hour dinner experience while rolling along the shoreline. All aboard!

NO. 71

Score big by experiencing the thrill of professional baseball watching the Pawtucket Red Sox

McCoy Stadium
1 Columbus Avenue, Pawtucket | www.pawsox.com

Root, root, root for the home team! What could be better than spending the afternoon watching America's favorite pastime? The home team out of Pawtucket is the minor league Triple-A affiliate of the Boston Red Sox, and they offer a major league experience at a minor league price. Bring a blanket and a bag of snacks then plop down on the lush green lawn behind the outfield fence. It's an intimate affair, and a lot of family fun.

NO. 72

Mill around in the many cool little antique shops in historic Chepachet Village

Antique shops of Chepachet Village
Chepachet Village, Glocester | www.chepachet.com/antiques.htm

For serious shoppers of antiques, you aren't going to find many places like the quaint and charming old country village of Chepachet. On US Route 44 (also known as Putnam Pike) in northwestern Rhode Island, Chepachet's streets are lined with rare antique and collectable emporiums. Plan on spending an entire afternoon browsing the many shops and hunting down one-of-a-kind bargains!

NO. 73

Defy gravity with a high-flying body workout while clinging to the silks at Arielle Arts

Arielle Arts
3377 South County Trail, East Greenwich | www.ariellearts.com

For something fun, healthy, and a little different, visit Arielle Arts and challenge yourself using their amazing aerial silks. Join a class or get private lessons on movements that will help increase your total body strength and improve your flexibility. The huge, colorful studio has lots of curtain-like durable silk material hanging in pairs of strips from the ceiling, and lots of elevated hoops to assist you in defying gravity. Now this is a way to get some exercise!

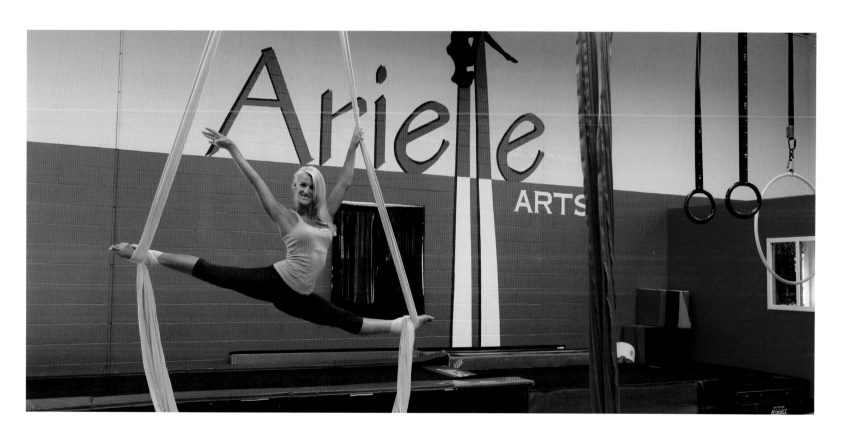

NO. 74

Take the jump from 10,000 feet with Skydive Newport and experience Rhode Island from the clouds

Skydive Newport
Newport State Airport
211 Airport Access Road, Middletown
www.skydivenewport.com

"When the door to the plane opens, put your feet on the step and cross your arms across your chest." Frightening! Well, if you ever wanted the life-changing experience of jumping out of a plane, you might as well do it with Skydive Newport. Your instructor, who is also your tandem jumping partner, will put you at ease as you both jump out of the plane at 10,000 feet. Go ahead and scratch skydiving off your "bucket list."
Photo courtesy of Skydive Newport

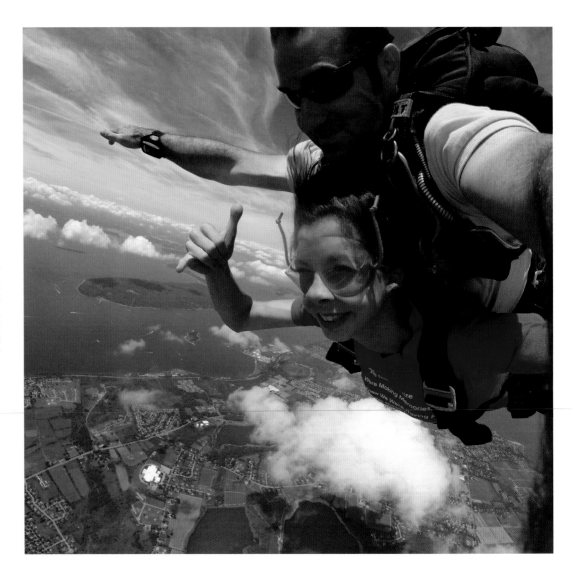

NO. 75

Treat the kids to Adventureland, and let them enjoy the mini-golf, go-karts, and bumper boats

Adventureland
112 Point Judith Road, Narragansett | www.adventurelandri.com

Adventureland Family Fun Park is the perfect destination for your little thrill-seekers and sport enthusiasts. They can spend the afternoon challenging their friends to a game of eighteen-hole mini-golf on the giant mountain, spraying each other from water guns while riding the bumper boats, or racing gas-powered go-karts. There are also trick basketball hoops, a Victorian-style carousel, and lots and lots of batting cages.

NO. 76

Wait until the sun sets, then explore
the haunted history of Providence
on a ghost tour

Providence Ghost Tour
Prospect Terrace, 60 Congdon Street, Providence | www.providenceghosttour.com

Have you ever seen a ghost? If not, you might just get your chance on the Providence Ghost Tour. Your guide will lead you by the murky glow of lantern light through the darkened streets of the historic East Side and reveal tales that will surely send a chill down your spine. The night-time tours meet near the giant statue of Roger Williams high up Prospect Terrace on Congdon Street. **Tip:** It's highly recommended to bring a camera.

NO. 77

Roam around the funky farmyard bazaar and shopper's paradise known as the Fantastic Umbrella Factory

Fantastic Umbrella Factory
4820 Old Post Road, Charlestown | www.fantasticumbrellafactory.com

Don't let the name mislead you: the Fantastic Umbrella Factory is definitely not a factory. Instead, it's an amazing collection of eclectic shops and whimsical gardens found along little paths that wind around what appears to be an old wooded frontier town gone hippie. Expect to come across unique jewelry, vintage eyewear, stained glass, casual clothing, resident animals, a bamboo forest, and yes, you might even find that colorful umbrella you've been looking for!

NO. 78

Grab a glass of champagne and flaunt your hat while watching a match at the Newport Polo Grounds

Newport International Polo Grounds & Pavilion at Glen Farm
250 Linden Lane, Portsmouth | www.nptpolo.com

You really don't need to be an aficionado of the sport to understand that the Newport International Polo Series at Glen Farm is really a lot of fun. Play starts at 5:00 p.m. on Saturday evenings, but you'll want to put on your best bonnet and arrive many hours earlier. You can park right along the field and have an elegant tailgate party or spread out a blanket and enjoy your champagne. Then walk around and mingle with high society, enjoy the classical music on the speakers, or play Frisbee on the lawn. Then let the match begin!

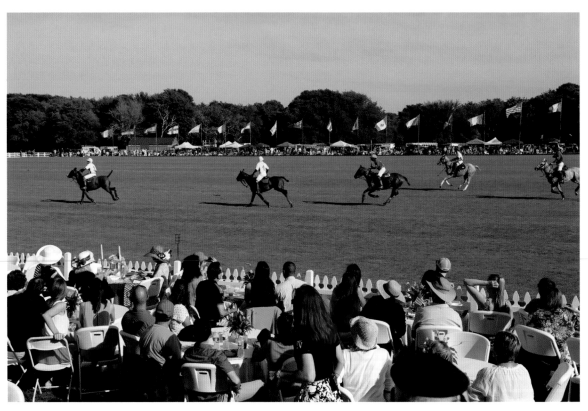

Triple Murder Burger
with an egg on top

Milkshakes

Chocolate	Oreo Caramel
Vanilla	Strawberry Chocolate
Strawberry	Coffee Caramel
Coffee	Banana
Caramel	Chocolate Banana
Oreo Cookie	Banana Oreo
Black 'n' White	Chocolate Mint
Moca	Oreo Chocolate
Oreo Coffee	Mango Strawberry
Oreo Strawberry	Mango

NO. 79

Order up some classic diner fare at the Haven Brothers Food Truck, the nation's oldest restaurant on wheels

Haven Brothers Diner
12 Fulton Street, Providence

It all began in 1888 with Anna Haven and her horse-drawn lunch wagon. Today, it's the oldest operating American diner on wheels. World-famous Haven Brothers Diner has been featured on NBC's *Today Show* and parodied on *Family Guy,* and rightfully so. The legendary diner, known for their tasty burgers and classic cheese fries, gets towed to its perpetually reserved curbside location outside City Hall each evening at 5:00 p.m. Then they feed city workers, local college students, and late-night partiers until 4:00 a.m. It's late-night dining at its best!

NO. 80

Dance to some great live jazz and blues at one of the many beach festivals held in Rhode Island

Blues on the Beach
Westerly Town Beach, 365 Atlantic Avenue, Westerly
www.bluesonthebeachri.com

If you want to listen to some great live music but don't want to spend a lot of cash for admission, you've got to try one of the many free beach concerts held during the summer. One of the more popular events is the Blues on the Beach series, held each Wednesday night at 6:00 p.m. on Westerly Town Beach. There are two sandy dance floors set up on each side of the stage, so get ready to boogie.

Blues on the Block
Fred Benson Town Beach, 7 Corn Neck Road, Block Island | www.blockislandinfo.com

Another popular summer series is Blues on the Block, concerts held behind the Fred Benson Pavilion on Block Island. The pavilion is in the heart of Crescent Beach, which locals refer to as Town Beach. Join in on selected Wednesday evenings and you can dance the sand right off your feet listening to some of the best blues and jazz acts in New England. Bring a beach chair or a blanket and hang out with the swinging locals and have the Atlantic Ocean as your backdrop.

No. 81

Take flight and check out Newport from the air with a ride on Bird's Eye View Helicopters

Bird's Eye View Helicopters
211 Airport Access Road,
Newport Airport, Middletown
www.riaerial.com

Up, up, and away! If you think Newport, Castle Hill, and those magnificent mansions on Bellevue Avenue look spectacular from the ground, just wait until you see them from the air! The smooth-gliding helicopters at Bird's Eye View can accommodate up to three people, and they offer different fun tours like a sunset ride or a Newport Mansions tour. So go on up in a whirly bird and have a really memorable experience.

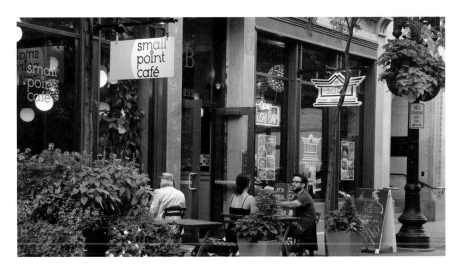

No. 82

Explore the streets of the Downcity Arts District,
a resurgent neighborhood of arts, boutique shops,
and restaurants

Downcity Arts District
Between Dorrance and Empire Streets, Providence | www.shopdowncity.com

The downtown area is fashionable again thanks in part to the resurgent Downcity Arts &
Entertainment District, Providence's historic shopping core. Bounded by the three parallel
"W" streets—Washington, Westminster, and Weybosset—from Dorrance to Empire, the district
is home to unique shops, a variety of restaurants, entertainment, theaters, and loft apartments.
The University of Rhode Island has its downtown campus here, as does Johnson & Wales
University. The college students and creative artistic influences help add to Downcity's young,
vibrant atmosphere.

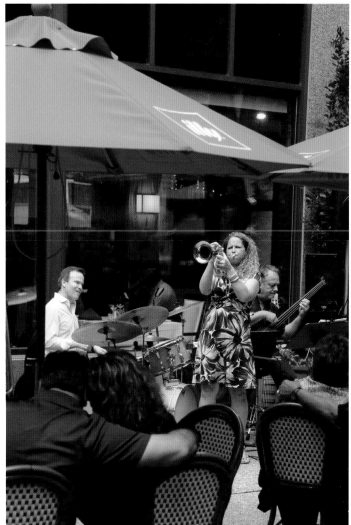

NO. 83

Hang out with the locals and enjoy the
great craft beers at Pour Judgement,
Newport's quintessential neighborhood bar

Pour Judgement Bar & Grill
32 Broadway, Newport | www.pourjudgementnewport.com

Whenever you visit a new city you can really learn a lot about the place and its people by
dropping in at the popular, local watering hole. And in Newport, that would be Pour Judgement
Bar & Grill. Not only do they have a solid, extensive lineup of great microbrews, but their
food menu rocks! There is always a creative list of good, affordable dinner specials, and don't
hesitate to add on an order of their legendary Gouda fries. Like they say, "When is the last
time you used Pour Judgement?"

NO. 84

Embark on a spiritual journey during a walking meditation of the Sacred Labyrinth

Sacred Labyrinth
Corn Neck Road, New Shoreham, Block Island
www.blockislandinfo.com/island-events/sacred-labyrinth

Up on the hilltop overlooking Sachem Pond is an ancient tool for prayer and meditation known as the Sacred Labyrinth. A labyrinth is a single circular winding path that leads to the center point and back out again. People report that walking the labyrinth can heal the body, quiet the mind, and open the soul, evoking a feeling of wholeness. Just start following the path, and let the spirit within you guide you on your sacred journey!

NO. 85

Crack open a succulent lobster at Quito's, Bristol's casual, legendary, water-front seafood restaurant

Quito's Restaurant & Bar
411 Thames Street, Bristol | www.quitosrestaurant.com

What started as a local fish market in 1954 has expanded into a gem of a family-friendly restaurant on the harbor in Bristol. Quito's gets high praise for their generous lobster rolls, great pasta dishes, fish and chips, and of course, their lobster dinners. They've got a very casual indoor dining room with a little fireplace for colder weather, but the covered patio along the water is the reason for the long lines.

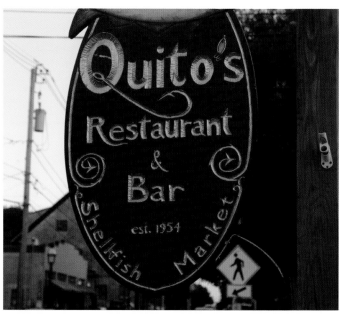

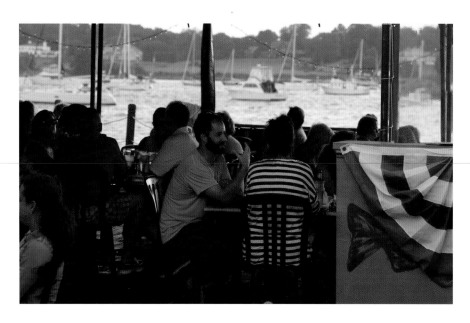

NO. 86

Discover the wonders
of nature at the McIntosh
Wildlife Refuge

Claire D. McIntosh Wildlife Refuge
The Audubon Society of Rhode Island
1401 Hope Street (Route 114), Bristol | www.asri.com

For a peaceful afternoon bonding with nature, grab your binoculars and head on over to the McIntosh Wildlife Refuge in Bristol. The twenty-eight-acre refuge has a nice walkable circular route that winds around an immense field, a path that meanders through the woods and wetlands, and a boardwalk that stretches all the way out to Narragansett Bay. **Tip:** Check out the Environmental Education Center near the entrance for a look at their rare blue lobster.

NO. 87

Hunt for treasures at Providence Flea, the upscale urban flea market along the Providence River

Providence Flea
345 South Water Street, Providence | www.providenceflea.com

The Providence Flea is this city's most popular upscale flea market. It's open on Sundays on the huge green space that borders the river and overlooks the downtown skyline. The eclectic open-air market features vintage treasures, interesting antiques, handmade jewelry, local artisan works, rare curiosities, live music, and lots of food trucks. And there is plenty of free parking along South Water Street. Happy hunting!

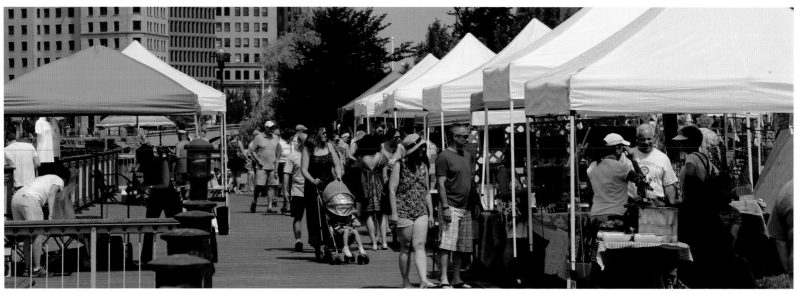

NO. 88

Venture out to Wright's Dairy Farm for their famous coffee milk and wonderful bakery, and to watch them milk the cows

Wright's Dairy Farm & Bakery
200 Woonsocket Hill Road, North Smithfield | www.wrightsdairyfarm.com

This really is what delicious tastes like! Do not miss the opportunity to travel out to Wright's Dairy Farm, a century-old working farm that has been operated by five generations of Wright family members. The bakery goods are absolutely mouth-watering, and they go perfectly with a container of fresh milk. And you have to try their coffee milk, which is a Rhode Island staple. Then hang around the farm and watch them milk the cows every day from 3 to 5 p.m. Keep Manhattan just gimme that countryside!

NO. 89

Take the gang out to Narragansett Town Beach and try to catch a wave on your surfboard

Surfing at Narragansett Town Beach
39 Boston Neck Road, Narragansett | www.narragansettri.gov

Narragansett Town Beach is a classic New England saltwater seafront revered for having some of the best surfing in the state. In the summer, the white sand and clear waters help attendance to swell to over 10,000 sun-worshipers a day, many of them eager to jump on a board and "hang ten." The waves are great, and you will have a ball watching all the surfers. **Tip:** The beach charges for admission but arrive after 5:00 p.m. and you can walk in for free!

NO. 90

Combine ocean views with majestic
mansions during the ultra-scenic 3.5-mile
Cliff Walk in Newport

Cliff Walk
Begins at the western end of Easton Beach, Newport | www.cliffwalk.com

One of the most prestigious and highly acclaimed walking paths in the country is the famed
Newport Cliff Walk. Meandering along the cliffs of Newport's shoreline, the 3.5-mile winding
trail offers breathtaking views of Narragansett Bay and the rocky cliffs on one side, and peeks
into the backyards of the elite who live in the grand mansions on the other. Some parts of the
path can be a little rugged, making this a rather adventurous outing.

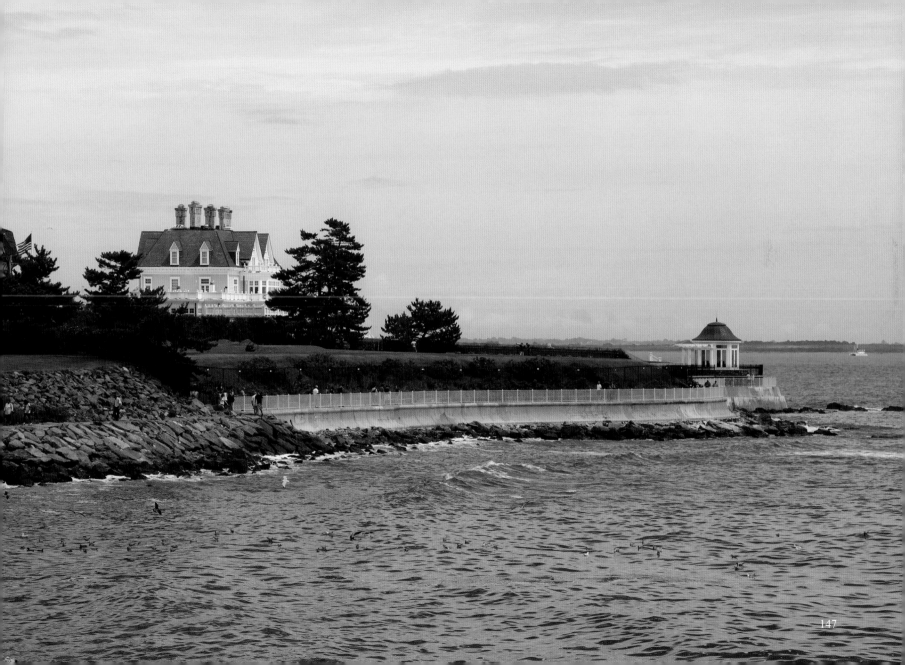

NO. 91

Stroll among the shrubs sculpted to resemble animals at the oldest topiary garden in the United States

Green Animals Topiary Garden
380 Corys Lane, Portsmouth | www.newportsmansions.org

Topiary gardening is the art of fashioning living plants to resemble figures, and the enchanting estate known as Green Animals in Portsmouth displays some of the finest. Created by Portuguese gardener Joseph Carreiro in 1905, the animals were developed by him and his son-in-law George Mendonca over the next eighty years. Follow the little paths and come upon bears, dogs, birds, a giraffe, a camel, an ostrich, and more than eighty more delightful sculptures. The site also features a series of lovely flower and vegetable gardens.

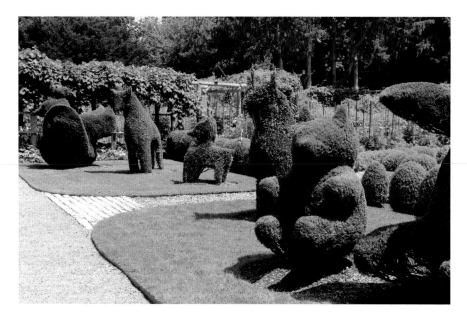

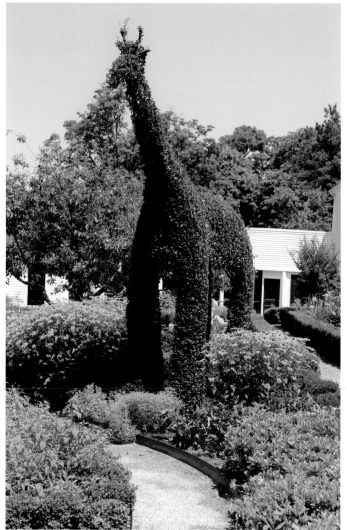

NO. 92

Pick up some fresh produce and flowers from a roadside honor stand, a Rhode Island tradition

Roadside honor carts
Throughout rural Rhode Island

Traveling along many of the country roads and byways in the great state of Rhode Island, you can't help but notice the number of folks that partake in the old-fashioned roadside tradition of colorful honor carts. Pull off the road next to these unmanned garden stands and smell the fresh-cut daisies, sample the homemade jams and jellies, and size-up the zucchinis and vine-ripe tomatoes. Take what you want and pay what you owe. Simply drop your money in the rusty can.

NO. 93

Bounce around on the wall-to-wall trampolines at Sky Zone Trampoline Park

Sky Zone Trampoline Park
70 Pawtucket Avenue,
East Providence
www.skyzone.com/providence

Remember how much fun it was to jump up and down in that little backyard trampoline? Well, magnify that by twenty! Sky Zone Trampoline Park in East Providence has over 15,000 square feet of wall-to-wall bounciness. You can jump around on your own, join a trampoline fitness class, dive into their remarkable foam pit, or join in on a game of bouncing dodge ball. It really is an enjoyable high-flying time! **Tip:** Invest in a pair of colorful Sky Zone jumping socks and you'll avoid blisters on your feet.

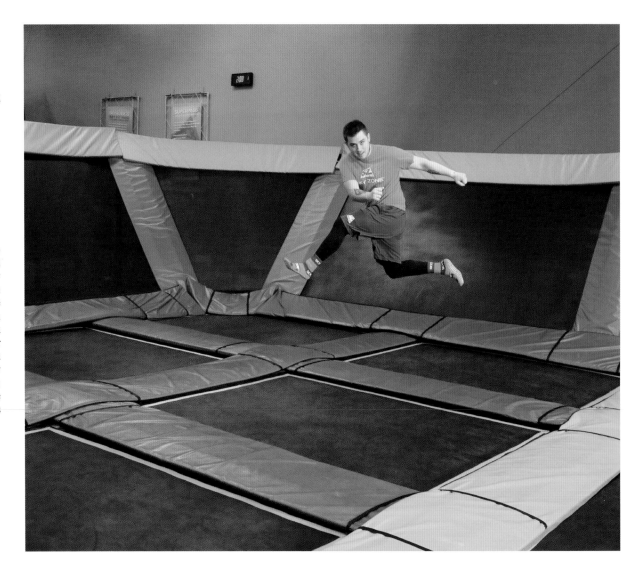

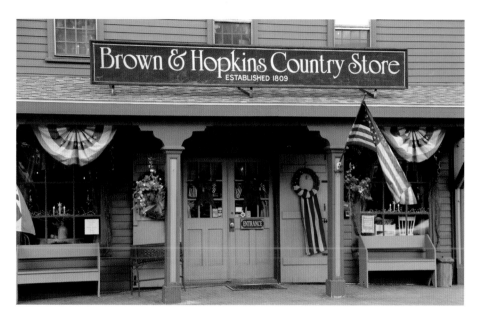

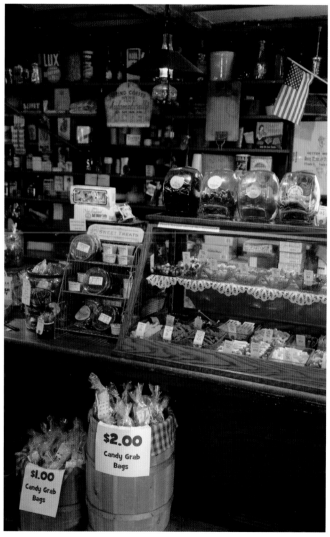

NO. 94

Splurge on the penny candy at Brown & Hopkins Country Store, America's oldest general store

Brown & Hopkins Country Store
1179 Putnam Pike, Chepachet | www.brownandhopkins.com

The village of Chepachet in northwestern Rhode Island is well revered for its outstanding antique shops, but the grand dame amongst the assemblage is the Brown & Hopkins Country Store. America's oldest general store in continuous operation, Brown & Hopkins opened in 1809 and, believe it or not, still sells penny candy for a penny! The enchanting shop is spread out over two charmingly creaky floors and is packed full of country goods, antique furnishings, quilts, candles, florals, gourmet specialties, and candy. Lots and lots of candy!

NO. 95

Relax with some wine and cheese on the iconic front porch of the National Hotel, overlooking the Old Harbor on Block Island

National Hotel
36 Water Street, New Shoreham, Block Island | www.blockislandhotels.com

When cruising into Block Island on the ferry, look a little to your right and you'll see her staring back at you. It's the stately National Hotel regally overlooking the Old Harbor and the sailboats. Don't worry if you are dressed casually, as the historic lodging is a "no-frills" kind of a place that makes you feel as if you are visiting someone's home. Its famous wrap-around front porch is *the* place in town to see and be seen for breakfast, dinner, or happy hour cocktails. It's a must-stop on the island!

NO. 96

Head to the beach and practice the fine art of rock balancing

Rock balancing on the beach
Mohegan Bluffs Beachfront, New Shoreham, Block Island

Fancy yourself an artist? Then just don't go to the beach for the sun and surf, but spend a little time inspiring a sense of magic and enjoying some peaceful tranquility by gathering the smooth beach stones and practicing the fine art of rock balancing. Walk around almost any beach in Rhode Island and you are sure to come upon someone doing what looks to be physically impossible. Grab some stones, steady your hand, and start balancing!

NO. 97

If it's Wednesday, dash out to the fast-paced Hermit Crab Races in Westerly

Hermit Crab Races at the Purple Ape
17 Winnapaug Road, Westerly

If you are at Misquamicut Beach and the sun is setting on a Wednesday in the summer, you have to head over to the Purple Ape on Winnapaug Road for the Hermit Crab Races. Start out by going inside the eclectic beach shop and picking out a colorfully decorated numbered crab. Then hang out under the canopy and wait for your number to be called. Ten crabs race fast and furiously (for a crab) to the circle's edge. The winner advances. It's really a hoot and a holler!

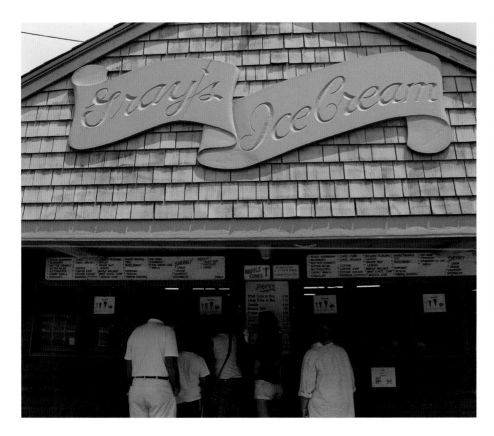

NO. 98

Savor a scoop of Rhode Island's favorite
frozen treat at Gray's Ice Cream

Gray's Ice Cream
16 East Road, Tiverton/259 Thames Street, Bristol | www.graysicecream.com

Consistently voted the state's best ice cream by local and national ice cream lovers alike, Gray's homemade frozen goodness is the real deal. The secret: they make their own delicious flavors from their own fresh dairy from their own cows! They've been a Rhode Island institution since 1923, scooping out scrumptious flavors like grape nut, maple walnut, and frozen pudding. Their ginger ice cream contains flecks of real ginger root. Yummy!

NO. 99

Take a peaceful stroll around the thirty-three-acre Blithewold Mansion, Gardens & Arboretum

Blithewold Mansion, Gardens & Arboretum
101 Ferry Road, Bristol | www.blithewold.org

One of the top public gardens in New England is found at Blithewold, a thirty-three-acre summer estate that neighbors tranquil Narragansett Bay. Formerly home to the Van Wickle family, the forty-five-room English-style manor is filled with family heirlooms and framed by a series of lovely flower gardens and a botanical area devoted to trees. The exotic grounds include an exceptional collection of rare plants, an accessible greenhouse, and incredible stonework throughout.

NO. 100

Visit the International Tennis Hall of
Fame and marvel at the memorabilia
and the lavish grass courts

International Tennis Hall of Fame and Museum
194 Bellevue Avenue, Newport | www.tennisfame.com

Wow, what a facility! The International Tennis Hall of Fame and Museum, set inside the newly renovated Newport Casino, fully immerses you in the history and heroes of tennis. You can view more than 25,000 tennis artifacts, hang out in a state-of-the-art holographic theater that will make you feel as though you are in the same room with tennis great Roger Federer, or play a game on one of their thirteen professionally manicured grass courts. Impressively done!

NO. 101

Get up early, realize you're on vacation, and go back to bed!

SWEET DREAMS AND HAPPY TRAVELS!

101 THINGS TO DO
(IN A HANDY LIST)

For your convenience, here's a quick-look reference list of all the suggestions in this book. Check off as many as you can each time you return to Rhode Island! And keep in mind, the list is in no particular order. I haven't put the "best" things first; each is wonderful in its own right. Also, some of the activities may be weather-permitting or held at scheduled times, so please check ahead for current updates and availabilities. I hope you get to experience all the wonderful things to do in Rhode Island, and that your visit will be memorable!

1. Celebrate a new day with the champagne buffet breakfast at the quaint, oceanfront 1661 Inn on Block Island

2. Tour the first cotton-spinning factory in America at Slater Mill, considered the "Birthplace of the American Industrial Revolution"

3. Buy freshly caught lobsters right from the boat at End-O-Main Lobster on Wickford Town Dock

4. Take a lighthouse cruise and get an eagle-eye view of the majestic lighthouses of Rhode Island

5. Admire the authentic African art and enjoy the calamari at CAV, one of Providence's landmark restaurants

6. Hang out around the fountain in DePasquale Square in Federal Hill and pretend you're in Italy

7. Pop in to the workspace of the bizarre and hilarious larger-than-life characters created at Big Nazo Lab

8. Pick your own blueberries right off the bush at Macomber's Blueberry Farm

9. Dig into a beloved Rhode Island tradition, a classic old-fashioned New England clambake

10. Ride the Flying Horses Carousel in Watch Hill, believed to be the oldest carousel of its type in America

11. Check out all the huge, multi-million dollar megayachts docked on Newport Harbor

12. Be inspired by the unique, handmade pieces available at the Field of Artisans, a weekly arts marketplace

13. Grab a camera and tour the many picturesque harbors throughout the Ocean State

14. Take a croquet lesson or attend teatime at the magnificent Ocean House, "the last of the grand Victorian hotels"

15. Enjoy one of the truly great original Rhode Island summer pleasures: a classic frozen lemonade from Del's

16. Join the hipster crowd for a fabulous brunch at Julian's, a local favorite

17. Simply take a seat, grab a snack, and sit back and admire all the fantastic sailboats

18. Take a romantic ride through the heart of Providence on an authentic Venetian gondola

19. Grab your binoculars and explore the wildlife along the pristine trails at the 325-acre Norman Bird Sanctuary

20. Explore the lives of ordinary tenant farmers in 1799 at the Coggeshall Farm Museum

21. Expose yourself to the full monty of a theatrical experience at the historic Theatre by the Sea

22. Gallivant around the quaint shops, restaurants, and parks of Pawtuxet Village

23. Shop, dine, sail, and stroll through historic Bannister's Wharf on Newport's harbor front

24. Crack open a bottle of wine at a shaded table overlooking the spectacular grounds at Carolyn's Sakonnet Vineyard

25. Jump on an elegant, turn-of-the-century sailboat and head out for an unforgettable sunset cruise

26. Have an egg roll served-up with legendary jazz and blues acts at Chan's Fine Oriental Dining

27. Roll the dice, play the slots, grab a drink, and enjoy world-class entertainment at the spectacular Twin Rivers Casino

28. Spend a relaxing afternoon riding the carousel and the swan paddleboats at Roger Williams Carousel Village

29. Celebrate your independence at Judge Roy Bean Saloon in Bristol, considered "America's Most Patriotic Town"

30. Attend a festival or pow wow presented by the Narragansett Indian Tribe, Rhode Island's original inhabitants

31. Scale the cliffs and enjoy the breathtaking views of Mohegan Bluffs on Block Island

32. Sip on a martini in an Adirondack chair overlooking the Atlantic Ocean at the luxurious Castle Hill Inn

33. Take an inspirational tour of Touro Synagogue, the oldest synagogue in America

34. Feel history come alive in the charming country setting at Prescott Farm

35. Grab a kite and some string and take advantage of the ocean breeze at Brenton Point State Park

36. Sample the unique and refreshing hand-crafted beers at Grey Sail Brewing of Rhode Island

37. Revel in the glow of WaterFire, the summer spectacle that spans the three rivers in downtown Providence

38. Cruise the three-mile stretch of classic, old-fashioned family fun along Misquamicut Beach

39. Take the ferry to Block Island, hop on a moped, and have a ball exploring

52. Spend a secluded, romantic evening in the rustic Rose Island Lighthouse on tiny Rose Island

53. Do a little shopping along the harbor in historic Wickford Village

54. Check out the sleek new look of Arcade Providence, the nation's oldest indoor shopping mall

55. Marvel at the endless art masterpieces at the internationally renowned RISD Museum

56. Savor a bowl of the Black Pearl's world-famous clam chowder on Newport's waterfront

57. Take the famous ten-mile oceanfront ride along scenic Ocean Drive, lined with parks, beaches, and lots of mansions

58. Rent your own kayak, or join a kayak tour, and paddle your way out to the ocean

59. Experience touring Broadway shows at the world-class Providence Performing Arts Center

60. Enjoy the awe-inspiring views and trendy cocktails at the upscale Rooftop at the ProvidenceG

61. Stroll down eclectic Thayer Street in College Hill and look into all the neat shops and restaurants

62. If you're a fan of *Downton Abbey*, don't miss the behind-the-scenes Servant Life Tour at The Elms

63. Spend the night singing and cocktailing at The Dean, the ultra-hip boutique hotel in Providence

64. Look over the history of yachting's most distinguished competition at the America's Cup Hall of Fame

65. Say a prayer at lovely St. Mary's Church, where a guy named John married a gal named Jacqueline

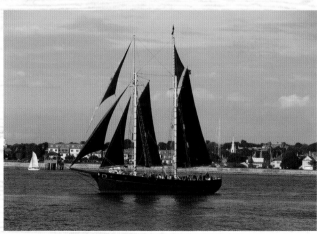

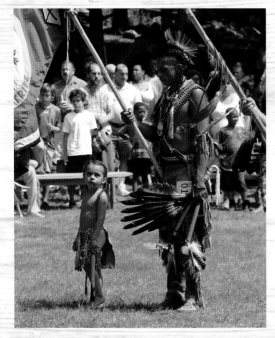

66. Strike up an evening of retro entertainment at Lang's Bowlarama

67. Soak up four centuries of the city's history with a walk along the Providence Heritage Trail

68. Rent a sailboat or take some lessons at Sail Newport, Rhode Island's largest public sailing center

69. Interact with one of Rhode Island's many creative local artists at a POP-Up or a Meet & Greet

70. Return to the golden days of rail travel and enjoy an elegant dining experience while traveling along Narragansett Bay

71. Score big by experiencing the thrill of professional baseball watching the Pawtucket Red Sox

72. Mill around in the many cool little antique shops in historic Chepachet Village

73. Defy gravity with a high-flying body workout while clinging to the silks at Arielle Arts

74. Take the jump from 10,000 feet with Skydive Newport and experience Rhode Island from the clouds

75. Treat the kids to Adventureland, and let them enjoy the mini-golf, go-karts, and bumper boats

76. Wait until the sun sets, then explore the haunted history of Providence on a ghost tour

77. Roam around the funky farmyard bazaar and shopper's paradise known as the Fantastic Umbrella Factory

78. Grab a glass of champagne and flaunt your hat while watching a match at the Newport Polo Grounds

79. Order up some classic diner fare at the Haven Brothers Food Truck, the nation's oldest restaurant on wheels

80. Dance to some great live jazz and blues at one of the many beach festivals held in Rhode Island

81. Take flight and check out Newport from the air with a ride on Bird's Eye View Helicopters

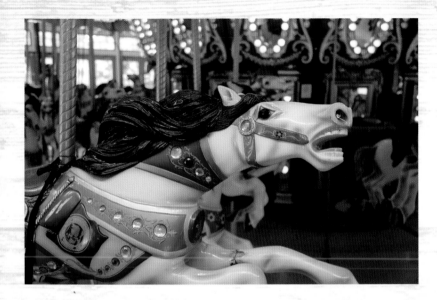

and wonderful bakery, and to watch them milk the cows

82. Explore the streets of the Downcity Arts District; a resurgent neighborhood of arts, boutique shops, and restaurants

83. Hang out with the locals and enjoy the great craft beers at Pour Judgement, Newport's quintessential neighborhood bar

84. Embark on a spiritual journey during a walking meditation of the Sacred Labyrinth

85. Crack open a succulent lobster at Quito's, Bristol's casual, legendary, water-front seafood restaurant

86. Discover the wonders of nature at the McIntosh Wildlife Refuge

87. Hunt for treasures at Providence Flea, the upscale urban flea market along the Providence River

88. Venture out to Wright's Dairy Farm for their famous coffee milk

89. Take the gang out to Narragansett Town Beach and try to catch a wave on your surfboard

90. Combine ocean views with majestic mansions during the ultra-scenic 3.5-mile Cliff Walk in Newport

91. Stroll among the shrubs sculpted to resemble animals at the oldest topiary garden in the United States

92. Pick up some fresh produce and flowers from a roadside honor stand, a Rhode Island tradition

93. Bounce around on the wall-to-wall trampolines at Sky Zone Trampoline Park

94. Splurge on the penny candy at Brown & Hopkins Country Store, America's oldest general store

95. Relax with some wine and cheese on the iconic front porch of the National Hotel, overlooking the Old Harbor on Block Island

96. Head to the beach and practice the fine art of rock balancing

97. If it's Wednesday, dash out to the fast-paced Hermit Crab Races in Westerly

98. Savor a scoop of Rhode Island's favorite frozen treat at Gray's Ice Cream

99. Take a peaceful stroll around the thirty-three-acre Blithewold Mansion, Gardens & Arboretum

100. Visit the International Tennis Hall of Fame and marvel at the memorabilia and the lavish grass courts

101. Get up early, realize you're on vacation, and go back to bed!

INDEX

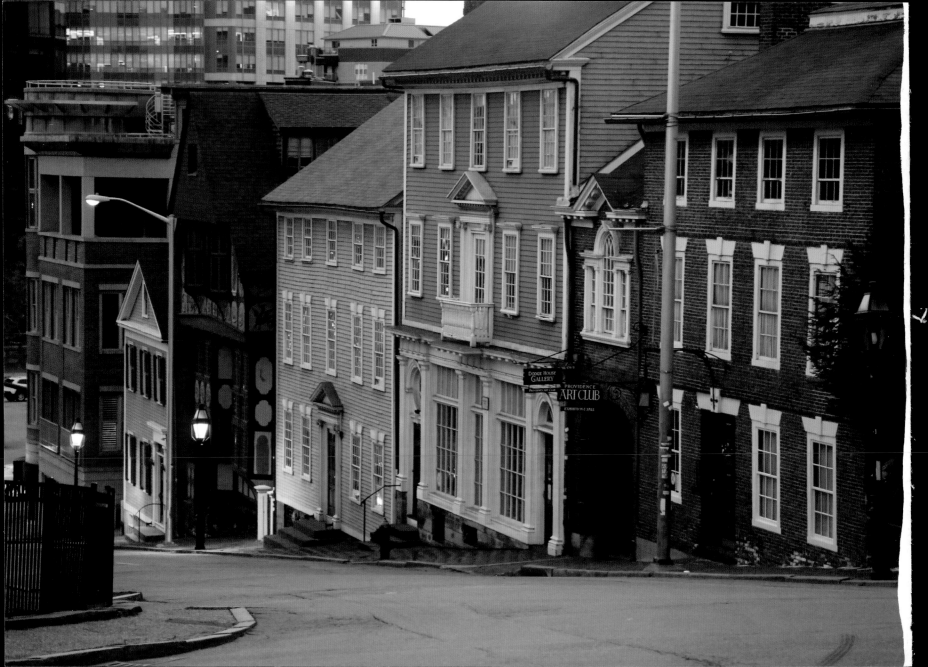